IMAGES
of London

CRYSTAL PALACE
AND THE
NORWOODS

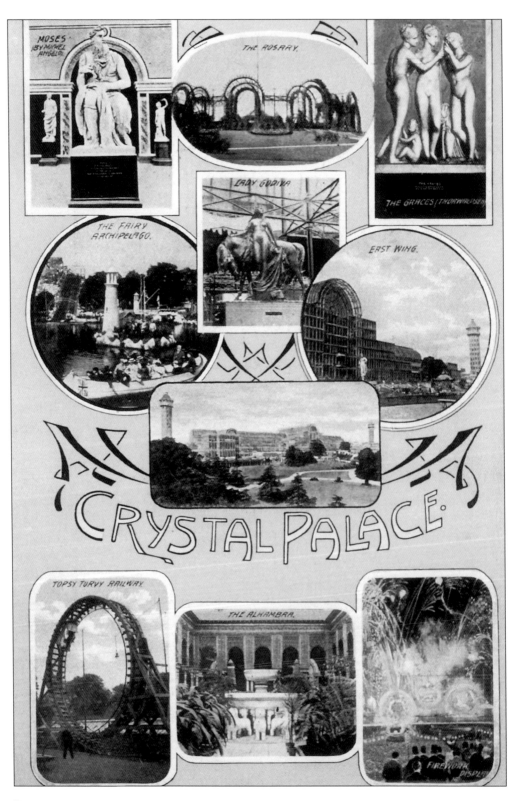

CRYSTAL PALACE.

IMAGES
of London

CRYSTAL PALACE
AND THE
NORWOODS

Nicholas J. Reed

TEMPUS

First published 1995, reprinted 2000, 2002, 2005

Tempus Publishing Limited
The Mill, Brimscombe Port,
Stroud, Gloucestershire, GL5 2QG
www.tempus-publishing.com

British Library Cataloguing in Publication Data.
A catalogue record for this book is available from the British Library.

ISBN 0 7524 0147 5

Typesetting and origination by Tempus Publishing Limited.
Printed in Great Britain.

Contents

Acknowledgements

The great majority of the pictures, including all those of the Crystal Palace, are from my own collection. I am most grateful to the following people for permission to use their photographs. The photos of the High Level Railway (pages 64-66) were all taken by R.C. Riley or A.A. Jackson. The photo on page 67 is reproduced by permission of Kentish Times Newspapers. The lower picture on page 68 is from Price-Harrison Cards. The photos on pages 70 and 71 were taken by Peter O'Kill. The lower photo on page 74 was supplied by Geoffrey Bensusan.

The following are from the local history collection in Upper Norwood Library: p. 82 (both), 84 (upper), 85(lower), 86 (upper), 98 (lower), 100-102 and 128. From the Archives Department of Croydon Library come p. 104 (upper), 106 (upper), 118 (upper), 119-121, 123, 124 (lower) and 125-127.

I am most grateful to Jerry Savage from Upper Norwood Library, Steve Roud from Croydon Library, and John Coulter from Lewisham Library, for their advice and helpfulness.

Introduction

It is almost 100 years since J. Corbet Anderson produced his book on Upper, West and South Norwood in 1898. This was the last book to consider all three Norwoods together, though Anderson specifically excluded the Crystal Palace from his work. Yet these three suburbs have much in common, all being influenced by the presence of the Palace, which drew both affluence and great artistic activity to the area. South Norwood turned into a more industrial area, encouraged by its excellent railway connections, whilst West Norwood quickly took on an unusual identity as the seat of the finest and most fashionable cemetery in London.

My own introduction to Norwood was living there as a boy from 1952 to 1957, but I have rarely lived far from it or the Palace site. Despite the absence of the Palace, activities by the various voluntary organisations, such as the Norwood Society and the Crystal Palace Foundation, kept one returning, all the more so when I produced a book about Camille Pissaro's stay in Norwood, and tried to identify the seventeen paintings he produced on his walks around the area. In 1989 I set up a society to raise funds to restore some of the listed monuments of famous people buried at West Norwood. Little did I suspect that within six months we would be organising a national campaign to stop Lambeth Council continuing a programme of wholesale demolition throughout the Cemetery. Our campaign succeeded, though we still have far to go in convincing people of the outstanding nature of the monuments in such an apparently unprepossessing spot. (Tours still take place there on the first Sunday of the month: 2.30pm in Summer, 11.00am in Winter.) But as the reader will see, there are still several unusual and distinctive buildings remaining in that suburb.

Woodside turns out to be the likely home of a mysterious bearded photographer of the 1890s, who put together a historical scrapbook now in Croydon Archives. Several photographs from it are reproduced in the last two sections of this book. It can be enjoyable to identify such pioneers. Back in the 1970s, I was shown two albums in Lewisham Library of extremely early photographs of Lewisham, taken by a keen amateur in the 1850s. His identity was unknown, though it was suspected he lived in a house in the High Street, whose back garden featured in some of the photographs. By chance, I noticed some of the same pictures reproduced in Duncan's History of Lewisham (1908), which thanked a Mr Henry Wood (no relation) for the loan of his early photographs. On investigation, it turned out that he did indeed live at the house whose garden was featured. Similar detective work could reveal the identity of the Woodside photographer. Indeed, it is worth noting that the photograph showing him at Woodside Green was copied from a framed picture brought into Croydon Library, but at a time when librarians were not so meticulous in noting the details of their informants. If that photo is still in the hands of the descendants, we may soon know far more about him.

Such identifications often depend on chance, and one cannot believe that such assiduous photographers and compilers wanted to remain unknown. It just does not occur to them that once their work is inherited by a non-relative, or given to a public authority, its origins are only too likely to be forgotten. If such compilers would just write their name and date of compilation in the front of such a book, its value as a record would be greatly enhanced. As a smaller adjunct to that, there are many photographs of the last century which show crowds at what must have been important local events. But what was going on, and even where they took place, is so often unknown, and will probably tantalise us for ever. It only takes a moment to write the occasion

and the date on the back of the photo: once done, the information is there for as long as the photo exists, and may add greatly to our knowledge of an event.

Several of the pictures reproduced are of drawings in a fascinating work entitled *London City Suburbs* by P.Fitzgerald, published by the Leadenhall Press in 1893. They do not seem to have been used in a historical work before, though one often sees the individual drawings framed as pictures for hanging. They are described as drawings by W.Luker junior, yet the figures in them, and sometimes the blurred nature of their depiction, suggests that many, and I suspect all, were based on photographs. At that time, books could not reproduce photographs, only line drawings, so Mr Luker's efforts were the only economic way of illustrating the book. His pictures can therefore be regarded as virtually as trustworthy as a photograph of the same scene: the more valuable in that in most cases, comparable photographs of that date are not known. (One wonders what happened to Mr Luker's originals?)

Lastly, a word on viewing the sights herein. Many of the views, in these inner London suburbs, are along roads which are now clogged with traffic. It is very unpleasant, and often dangerous, to spend any length of time examining the modern scene. In addition, the traffic along such roads is now so heavy that the addition of the rush hour or even the 'school run' can bring it to a halt for several minutes. Ironically, the best way nowadays to view these sights is often to sit in a motorcar in the thick of the traffic at any time between 3.45pm and 5.30pm, and examine the architecture in detail, and comparative quiet, before the traffic crawls along to its next halt. One hopes this advice will eventually be superseded by the introduction of better public transport in this area. There is no sign of it yet.

Nicholas Reed
September 1995

Introduction to the Revised Edition

Since 1993 I have been Editor of the *Norwood Review*, published by the Norwood Society, which has introduced me to several extra sources of material on the area. I am also grateful to several correspondents, including Mr J. Law and Winifred Bamforth, for some small corrections, and especially to John Coulter, author of the magisterial *Norwood Past* (1995), who has made some very helpful comments and suggestions.

The most frequent change in this edition has been to update the many pub names which, having lasted for two or three centuries, have now been altered to that of pub chains: in effect, wiping out their history at a stroke. The only good thing about this sad and silly trend is that at least the buildings have not been demolished, and the names can be changed back when good sense prevails. (In Penge, for example, the 300-year-old Crooked Billet has thankfully got its name back, after a few years' aberration.) In the meantime, we must put up with The Quality Hotel instead of The Queens Hotel and O'Neill's instead of the White Hart. Most ridiculous of all is The Orange Kipper instead of the Queens Arms. Do the proprietors want to perpetuate Protestant bigotry in Norwood, while it slowly disappears in a more peaceful Ireland?

I should like to dedicate this new edition to the memory of my father, Ronnie Reed (1916-1995), whose enthusiasm for local history and its surviving buildings encouraged my own.

Nicholas Reed
January 2000

One
The Crystal Palace

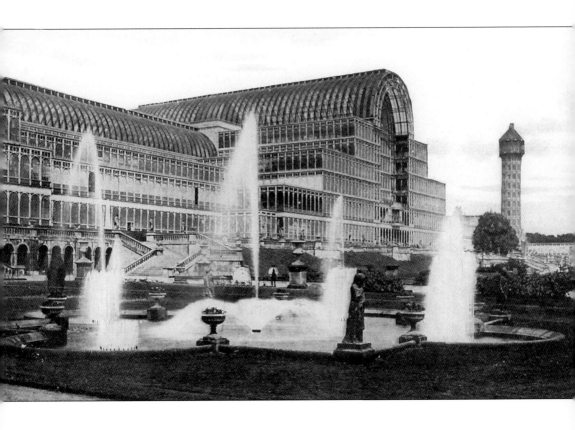

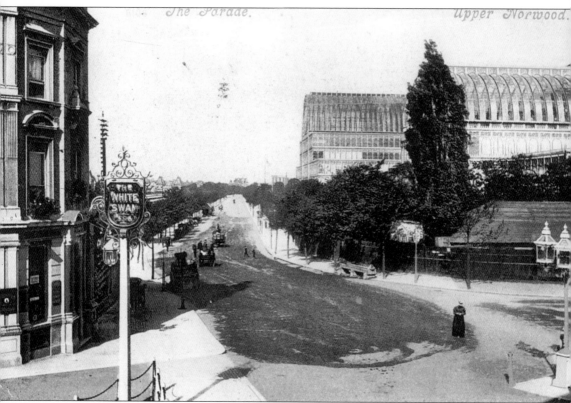

The Crystal Palace was built in Hyde Park in 1851, to house the very first International Exhibition. After the six-month duration of the Exhibition, the building's designer, Sir Joseph Paxton, wanted it to be a permanent feature, and raised the money for it to be dismantled and re-erected at Sydenham. When reopened in 1854, it was three times larger, and was surrounded by 200 acres of grounds, with an extensive variety of plants, fountains and statues. The composite card reproduced on page 2 gives some idea of the variety of attractions to be seen at the Palace at the turn of the century. There were also frequent temporary Exhibitions held inside the building. The Palace itself burnt down in a spectacular fire in 1936. The above was taken from the top of Anerley Hill in about 1905, looking north along Crystal Palace Parade. The White Swan Tavern, whose history goes back at least to 1870, is visible on the left. On the right, part of the Palace itself. The top photograph on the next page was apparently taken by the same photographer on the same day. His viewpoint must have been a window of the Cambridge Tavern.

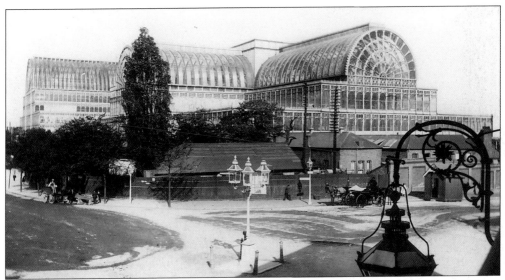

This time we see a full side view of Crystal Palace building, across what is now the roundabout at the top of Anerley Hill, before the installation of the trams. The horse trough on the left was particularly needed by horses which had climbed up Anerley Hill. If only some of the splendid Victorian gas lamps and brackets had survived!

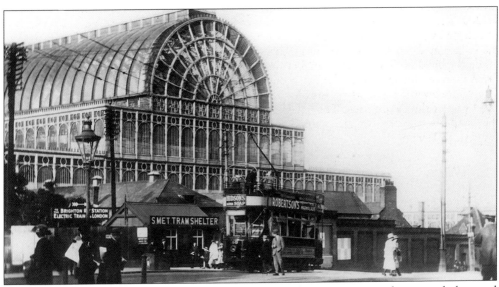

To the right of the above, some twenty years later. This time we see the tram shelter and terminus at the top of Anerley Hill. The Victorian gas lamps have already been replaced by less elaborate ones. Just down the hill to the right is now the Crystal Palace Museum.

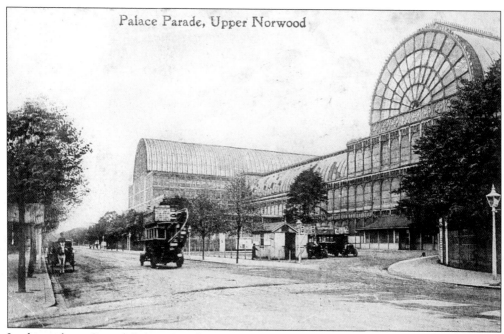

Looking along Crystal Palace Parade in about 1920. On the right, the main entrance and central transept of the Palace. An open-topped bus waits beside a simple busman's shelter, while another travels towards Sydenham.

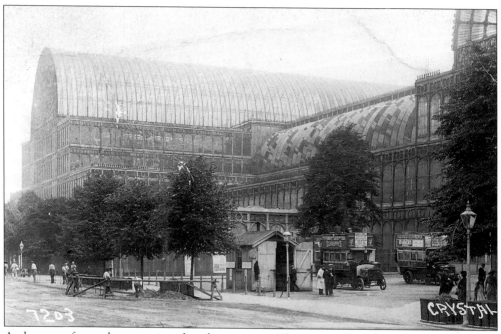

A close-up of more buses stationed at the entrance. The one on the left is a no. 3, advertising Schweppes; the other advertises Barker's department stores in Knightsbridge. This part of the Parade did not change for over a century: buses waited on the area and used it as a turning circle right up until January 2000, when the new bus station came into use further down.

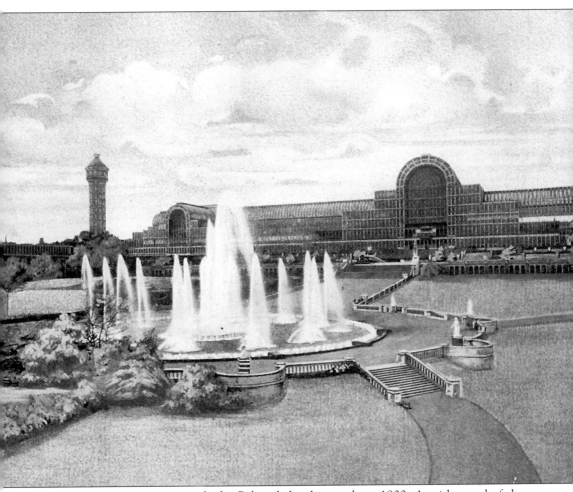

The Great Centre Fountain, with the Palace behind it in about 1900. At either end of the Palace stood two mighty watertowers: the south one is visible here. These held the water to power the fountains in the grounds. The original towers were square glass structures designed by Paxton: when they started to fill them in 1854, there was an ominous creaking and groaning, which led those in charge to empty them immediately. Isambard Kingdom Brunel was called in, and on his advice the towers were demolished, and new much stronger ones built of brick and concrete replaced them, to his design.

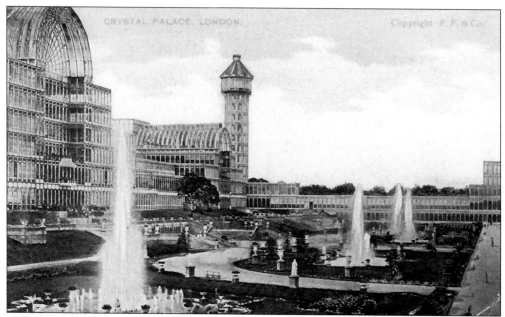

Two views of the central transept from the rear, with the North Tower in the distance. Just in front of the tower is the north transept. That is surprising, because although both these cards were produced in about 1905 - that below was posted in 1911 - the North Transept burnt down in 1866! This fire broke out in almost exactly the same place as that of 1936. But on the first occasion, the winds was blowing north, and simply consumed this wing. The Company could not afford to rebuild the transept, and so put gardens, and later a more lucrative funfair, on the site.

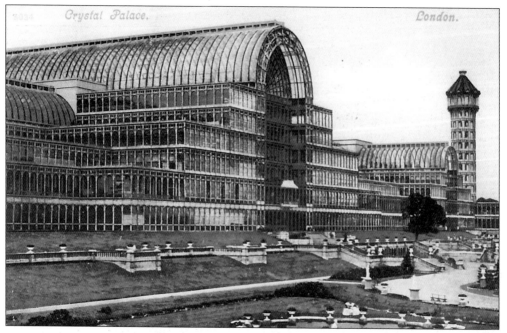

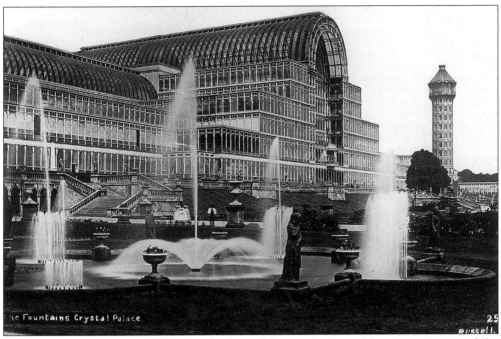

The Fountains Crystal Palace 25
russell.

Two views which try to make up for the loss of the north transept by showing more of the Italian Gardens in front. These gardens were restored to much of their original appearance by Bromley Council, after they took the park over from the GLC in 1986. Note that in two of these four cards, the fountains are working. In fact, they were only rarely put into operation: they were very expensive to run, took vast amounts of water (six million gallons for one display!), and later became rusty and generally abandoned. The lower card shows the two balustraded staircases leading to the southern steps flanked by two sphinxes.

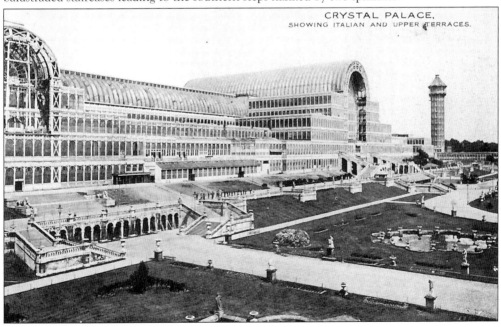

CRYSTAL PALACE,
SHOWING ITALIAN AND UPPER TERRACES.

15

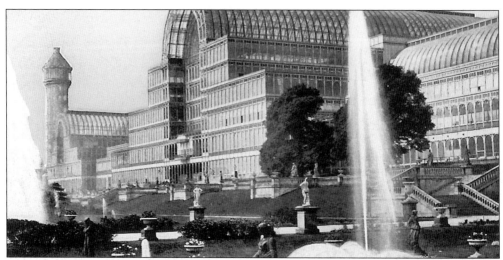

Closer views, this time looking south, of some of the ornamental statues and vases to be found on the Italian Terrace. It looks as though the publisher of the upper card, faced with empty fountain basins, actually painted in the water of the fountains, to make the picture more "realistic"! In the lower view, the steps have been extended by being raised on stilts to take the public up to a higher level of the Palace: this seems to have been done in 1911.

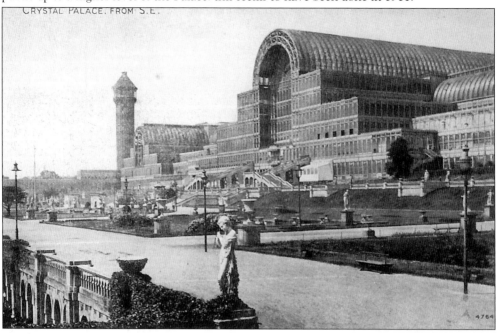

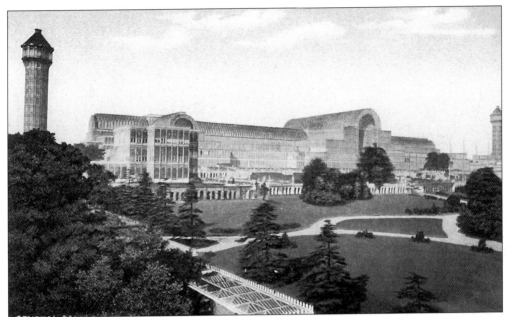

A more distant view from the southeast. In the foreground is the covered passageway which led up from the original station of 1854 ("Low Level Station") the quarter of a mile to the Palace, and sheltered the passengers in bad weather. This was all the more necessary once the other ("High Level") station was dropping them just beside the Parade, 100 yards from the Palace entrance.

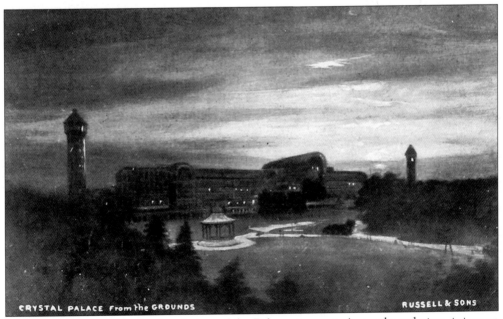

CRYSTAL PALACE From the GROUNDS RUSSELL & SONS

A somewhat romanticised painted view of the Palace at sunset. As a coloured view, it is most effective. Russell and Sons, publishers of this and some of the other Palace cards reproduced here, were based in the South Nave of the Palace itself.

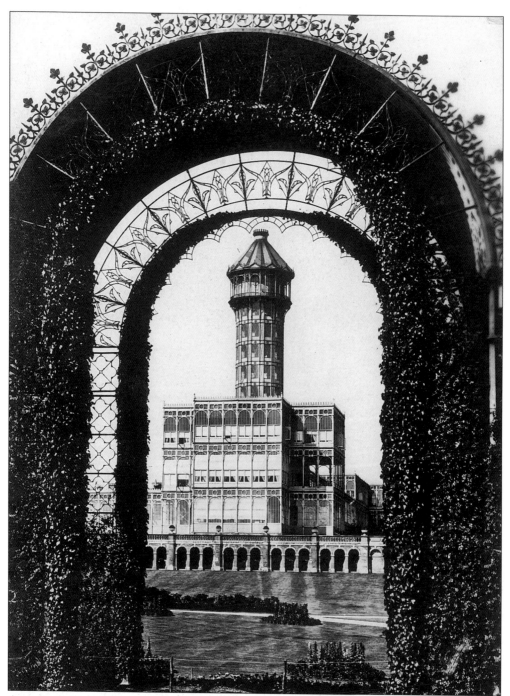

An artistically posed view, showing the South Tower and School of Art building in front of it, all framed by an arch of the Rosary. The School of Art was one of several Schools giving higher education here. Camille Pissarro's daughter-in-law Esther Bensusan attended it, shortly before marrying his eldest son Lucien Pissarro in 1892. The building was used by Baird in the 1930s for some of his TV experiments. It survived the 1936 fire, but was burnt down by schoolboy arsonists in 1950.

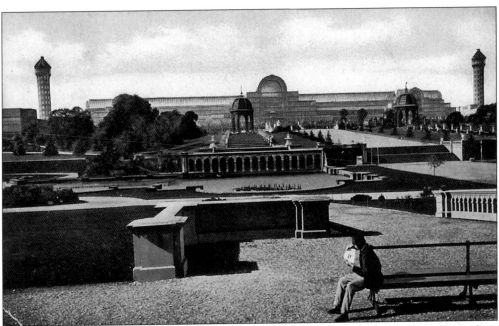

The two largest fountain basins, in the lower part of the grounds, were nearly 800 feet each in length. Being the least economic of all the fountains, they were filled in, in 1894. The South Basin shown above was converted to a football stadium, and the Cup Final was held here from 1895 to 1914: the second photo dates from about 1900. The two domes shown in the distance were of two 60-foot-high iron temples at the head of cascades of water. The disused cascades were removed in 1880, but the temples remained till later. The first photo above, though posted in 1906, shows the north transept, and so cannot be later than 1866. The site of this fountain is now used as the athletics track.

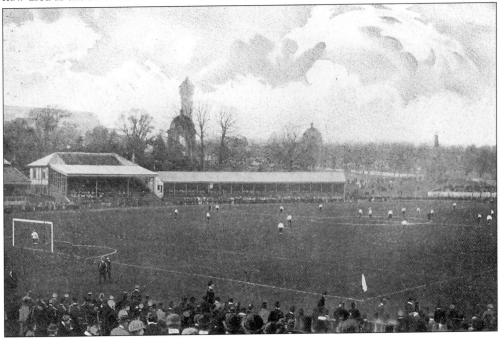

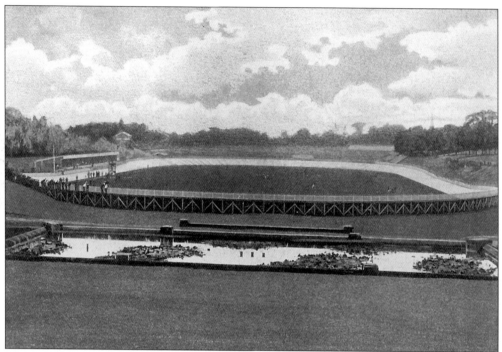

The North Basin was converted to a cycle track, and became one of the major tracks in the country, several records being set on it. The Sports Hall of the Recreation Centre now stands on its site. In the foreground of the picture can be seen one of the smaller rectangular fountain basins: its opposite number still survives at the other side of the Park.

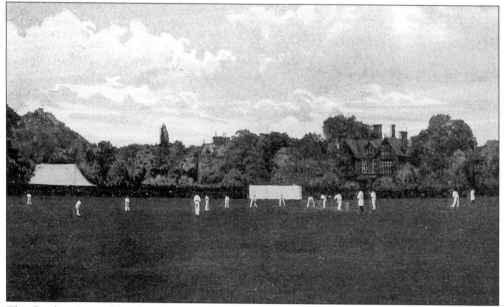

The Cricket Ground has lasted from 1857 till today. In 1898 it became the base of the London County Cricket Club, founded by no less a cricketer than W G Grace, who became its first Manager. He was living in Lawrie Park Road at the time, though that house has now gone, and the blue plaque was resited on his last home in Mottingham Lane.

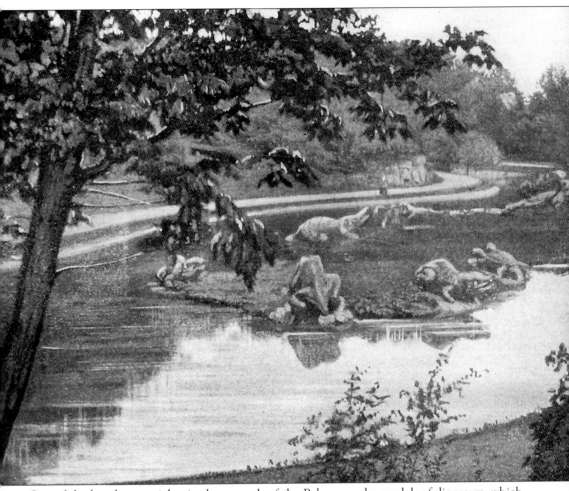

One of the best known sights in the grounds of the Palace are the models of dinosaurs, which are arranged in chronological order along a series of islands to tell the story of their development. They were sculpted by Waterhouse Hawkins under the direction of Professor Richard Owen, who coined the term "dino-saur", which is Greek for "powerful lizard". The picture above shows the smaller ones on the first island, and also shows that fifty years after their installation, trees and shrubs were kept off the island so the animals could be better appreciated. Since then, trees and shrubs have grown apace.

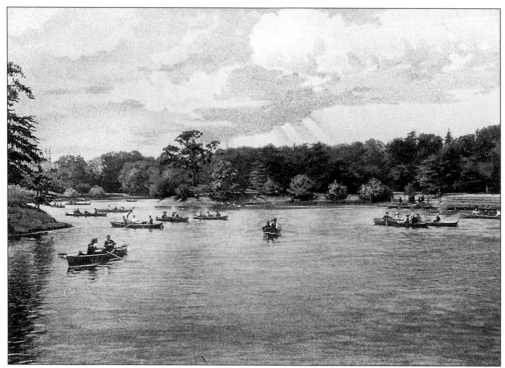

The boating lake, at the bottom of the park, was originally known as the "tidal lake", because its level fluctuated greatly. When the fountains were working, water from the lake was taken to operate the fountains during the day, then the lake was refilled at night, making it indeed seem tidal! The rowing boats of older days have now been largely replaced by paddle boats, operated by the legs. These are presumably regarded as safer by some, though others may think they are much less fun. The upper picture dates from c. 1900; the other from c. 1920.

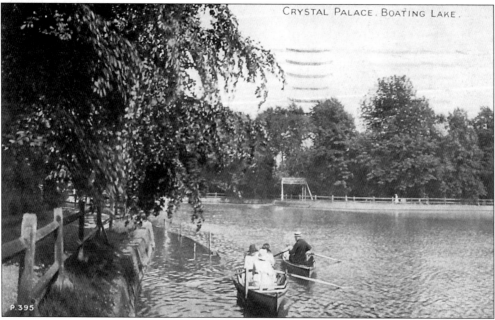

CRYSTAL PALACE. BOATING LAKE.

P. 395

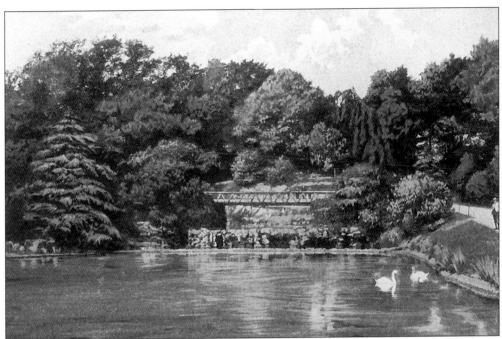

Two more views of the boating lake. The rustic bridge, seen from the east side in the upper picture, is still there, though the ironwork now has a metal grille on one side for safety reasons. Behind it still lie the remains of an artificial geological formation. This was built to show a fault line, where different layers fall out of line after an earthquake. This was another of the educational features of the park, along with a mock-up of a lead-mine, which was built inside the same hill, but is no longer accessible.

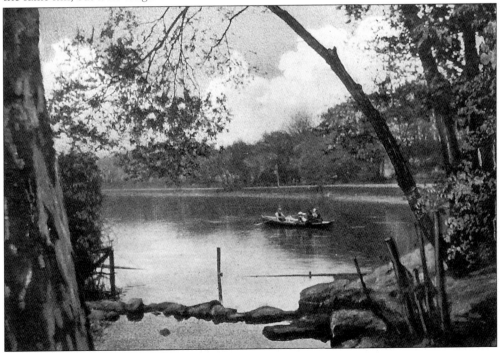

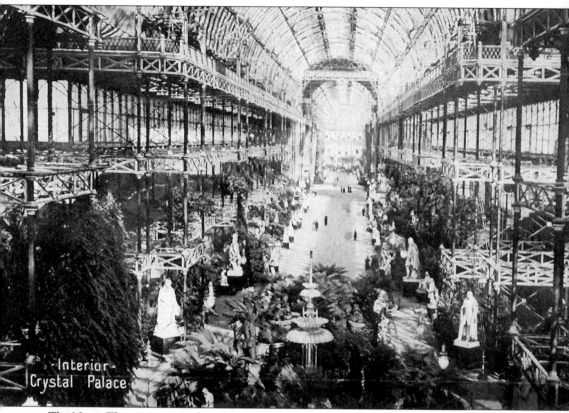

Interior - Crystal Palace

The Nave. This gives some idea of the vastness of the structure: looking along the entire length of the central apse. In 1851 the original building was planned to have a flat roof. Those who objected to the whole idea of the Great Exhibition, pointed out that the flat roof would necessitate felling several splendid elms growing on the proposed site. Brunel therefore suggested placing a transept across the roof, to enclose the tops of the trees. When the building was transferred to Sydenham and greatly expanded, this transept was used for the southern arch, while a far bigger transept was constructed for the centre of the new building. In some ways this main building can be seen as resembling the Palm House at Kew, but with the addition of a fountain and pond, in a vastly bigger building.

Opposite: The main feature here is the fountain: Osler's Crystal Fountain, as it was called. A feature of the 1851 building, it was transferred to Sydenham, and had bright flowers and large ferns around its side, while the pond had lilies on its surface and goldfish inside. After the fire of 1936, pieces of the crystal were (and still are) highly prized as souvenirs.

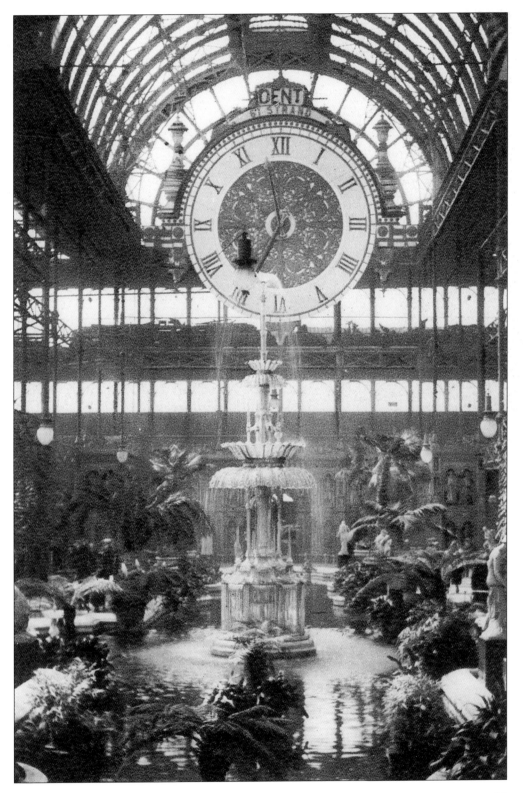

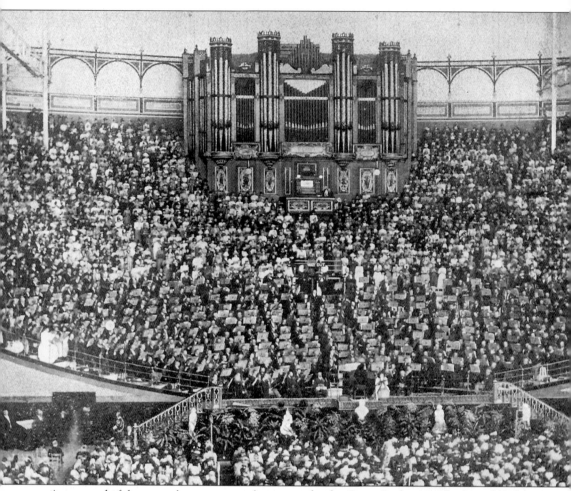

At one end of the central transept was the seating for the Great Orchestra, which could take up to 4000 performers, for example, for the Triennial Handel Festivals. Dominating the whole was the great organ, the largest in the country, with 4500 working pipes. Nearby was a Concert Room, seating 3000, and the Crystal Palace Theatre, which seated 2000.

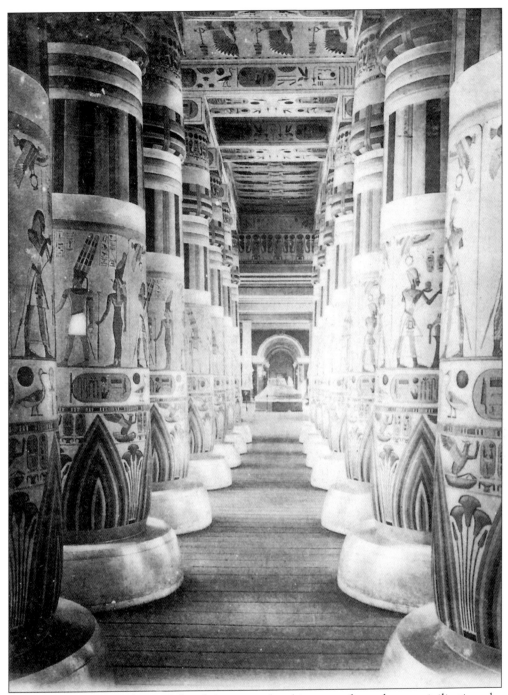

The Fine Art Courts. These exhibited the arts and architecture of most known civilisations, by means of elaborate and fully painted reconstructions and plaster casts. In effect, a type of Disneyland more than 50 years before Disney thought of it. In chronological order, the Courts started with the Egyptian Court. This had temple columns and statues, surmounted by a hieroglyphic inscription recording that the whole Palace was constructed, "with a thousand statues, in the seventeenth year of Queen Victoria's reign".

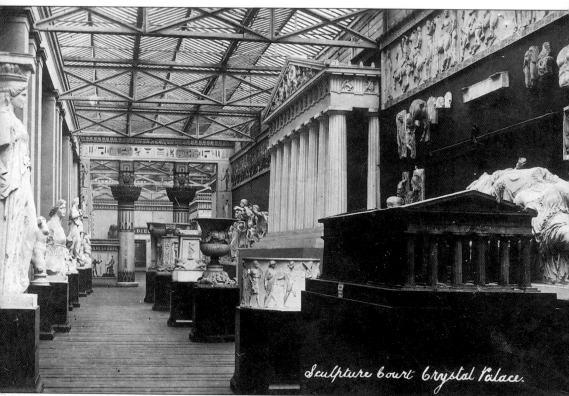

Sculpture Court Crystal Palace.

The Greek Court. This was partly based on the Temple of Jupiter at Nemea, and again everything was coloured according to the conjectures of the scholars. A similar Greek influence is shown in the Sculpture Court elsewhere in the Palace. In the picture reproduced, one can see (plaster casts of) a caryatid from the Parthenon at left and a leaning figure from the Elgin Marbles at right. A similar but larger sculpture gallery can now be seen at the Victoria and Albert Museum.

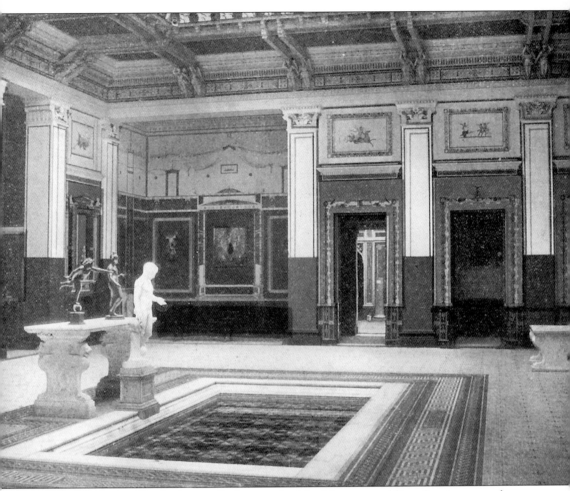

The Roman Court. This had its walls decorated with elaborate marbling. But it was outdone elsewhere in the Palace, where they reconstructed a complete house from Pompeii. This had Roman mosaic flooring and highly-coloured wall paintings. The nearest equivalent to this now, is the Getty Museum in America.

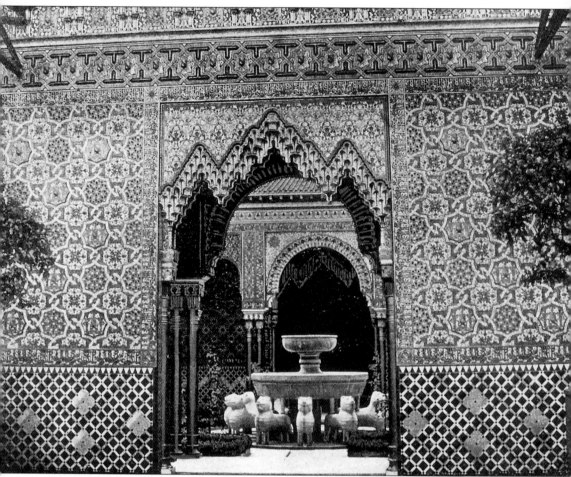

The Alhambra Court. This reconstructed, mainly at full size, four different sections of the 13th-century Alhambra Palace in Granada, Spain. With the Lion Fountain in the centre, it was surrounded with elaborate Moorish tilework. Beyond this came the Byzantine Court, which had examples of architectural styles from the 10th and 11th centuries, from several countries.

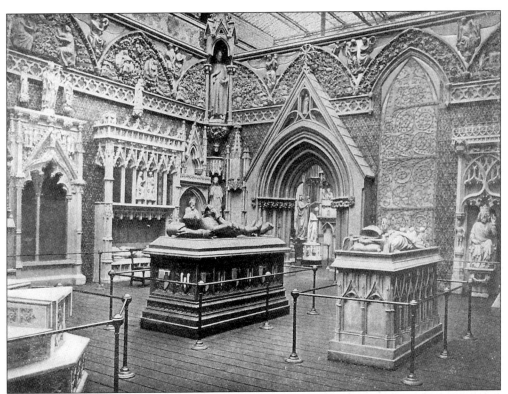

The English Medieval Court. This showed examples of the three main styles of church architecture, from the 12th to the 15th centuries. In most cases, such as the doorway to Rochester Cathedral, they were painted in the colours it was thought they originally had.

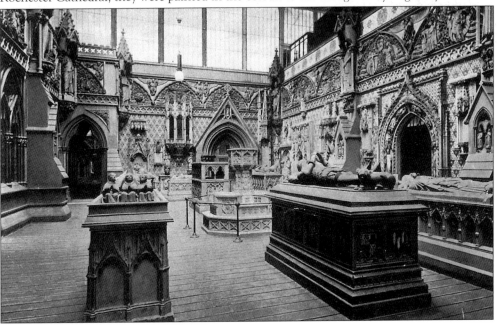

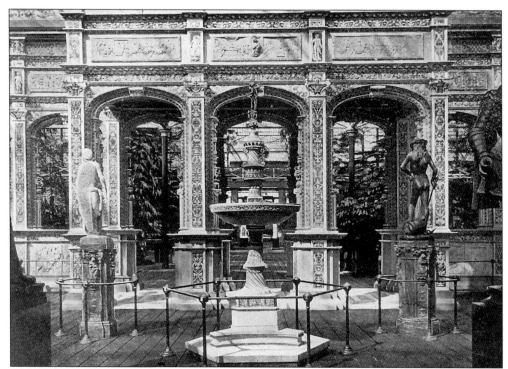

The Renaissance Court. This had examples of sculpture from a French chateau - the central fountain - as well as others from Venice, Florence, and even Nuremburg.

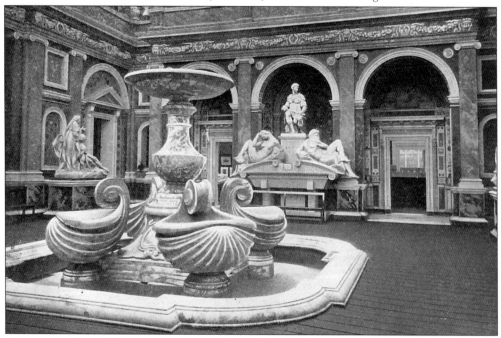

The Italian Court. This was based on the Farnese Palace in Rome, and included the Tortoise Fountain, and many Raphael frescoes. Beyond all these Courts were a Picture Gallery and a Portrait Gallery.

Two
The Festival of Empire

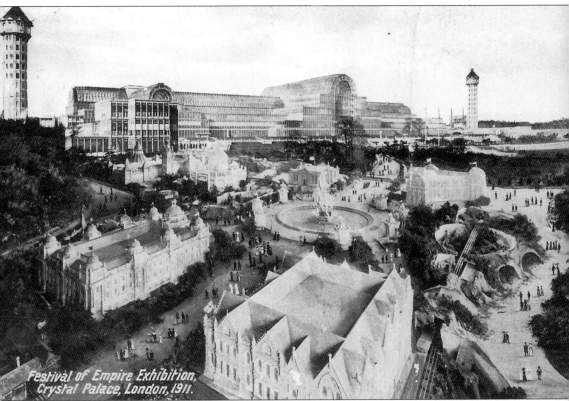

Festival of Empire Exhibition,
Crystal Palace, London, 1911.

One of the main features of the Festival of Empire, put on in 1911 to celebrate the British
Empire, was the construction in wood and plaster of three-quarter-size replicas of all the
government buildings in the British Commonwealth. Several of them are visible here, along
with the railway track, known as the All-Red-Route, which ran around the exhibits. The Red
Route referred to the fact that large parts of maps of the world were coloured pink, for "British",
at the time.

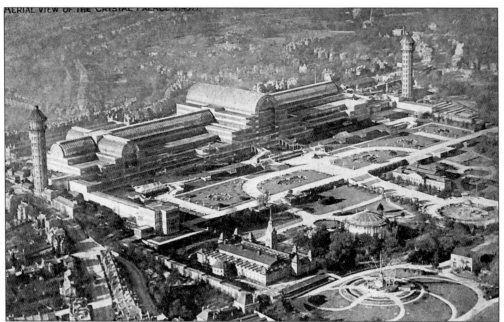

Aerial views of the Palace site in the 1920s. Most of the buildings visible in the grounds were left over from the Festival of Empire. In the foreground of the lower picture can also be seen the football stadium (left) and the cycle track (right).

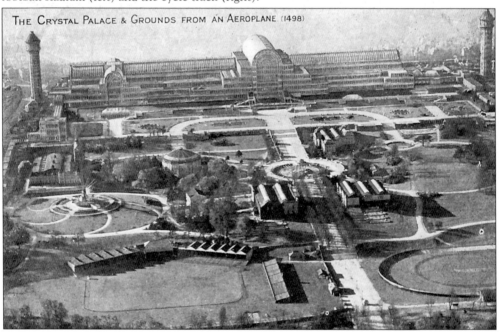

THE CRYSTAL PALACE & GROUNDS FROM AN AEROPLANE. (1498)

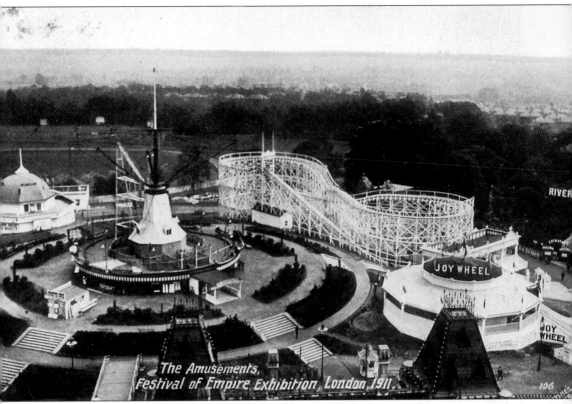

The Amusements,
Festival of Empire Exhibition, London, 1911.

Looking out from the roof of the large Festival building visible in the two previous photographs. Note the elaborate ironwork on top of the square turrets. Most of the fairground attractions shown here were erected for the 1911 Exhibition. The exception was the tall structure on the left: the Flying Machine of Sir Hiram Maxim. This was built on the site of the Rosary in 1904, and proved a popular attraction. People were swung round on flying boats suspended on cables which moved out as the turntable speeded up. Another such machine, built at Blackpool, is still in operation. Eight of the flying boats are visible in this photo, but as only five solitary men in dark uniform are patrolling, one can assume this photo was taken on a Sunday, when the boats were not in use.

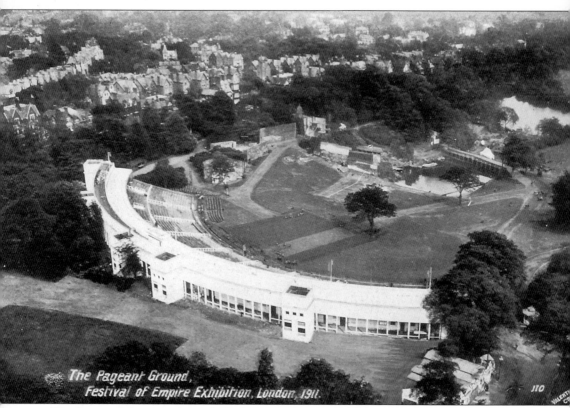

The Pageant Ground,
Festival of Empire Exhibition, London, 1911.

The layout of the ground on which the pageants were held in 1911, accurately prefigured what takes place there now: the open-air orchestral concerts, with the lake visible here now sited in front of the orchestra. In the distance, the split between the houses of Westwood Hill and Crystal Palace Park Road can be seen, with the houses of the latter continuing down beside the Park. This land just inside the Park was sold by the Company in the 1880s as building land, to try to lessen the losses they were experiencing in the rest of the Palace and grounds. The 1911 Exhibition was, in itself, a great success, with over 100,000 people attending. But it must also have been incredibly expensive. With the Company close to bankruptcy, they must have decided to put all their eggs - and their capital - in one basket. In other words, they went for broke, and sadly reached this destination all too successfully. The entire building and site were put up for auction, and likely to be sold off for building land. However, the entire site was bought by a philanthropist, who "saved it" for the nation. It lasted another twenty-five years.

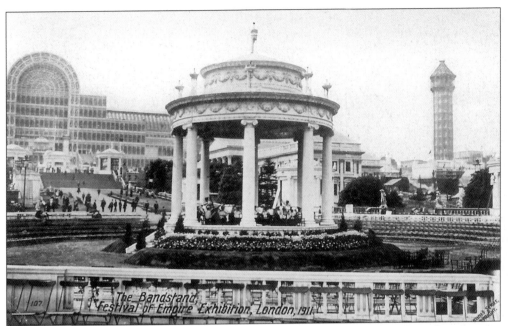

For the Exhibition, the Central Fountain basin was used for the Bandstand. In this view one can see a band playing, with the central avenue beyond, leading up to the Palace in the distance.

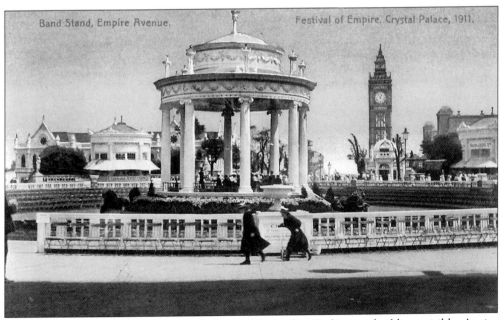

Looking in the opposite direction, with more of the replica Parliament buildings visible. Again, a band is playing, but once again, there is no audience! It is possible the band was so bad that no-one could stand it. Perhaps more likely they were practising.

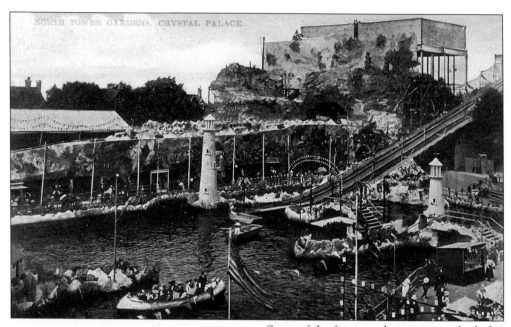

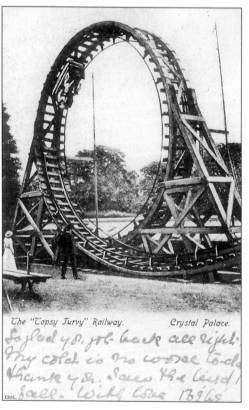

The "Topsy Turvy" Railway. Crystal Palace.

Some of the fairground attractions which the Palace introduced to try to maximise revenues. The Water Splash was built on the site of the North Transept, in the North Tower Gardens. At top right can be seen the two water tanks, one of which lasted till the 1980s. The Topsy-Turvy Railway is an early version of what has become a very common train ride, where centrifugal force keeps the train on the tracks even when it is upside-down.

38

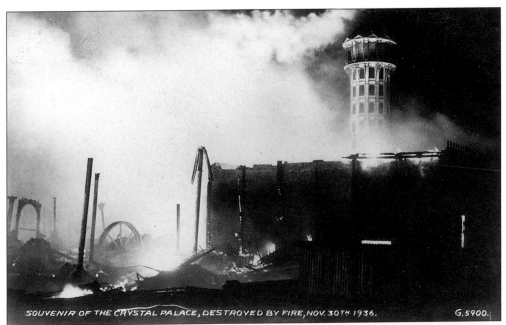

SOUVENIR OF THE CRYSTAL PALACE, DESTROYED BY FIRE, NOV. 30TH 1936. G.5900.

The cause of the dramatic fire, on the evening of 30th November 1936, is still unknown. Most likely it was a loose electrical wire shorting and sparking on the dry bare floor-boards. The glow from the fire could even be seen on the SE coast, and almost everyone within fifty miles found a viewpoint to watch it.

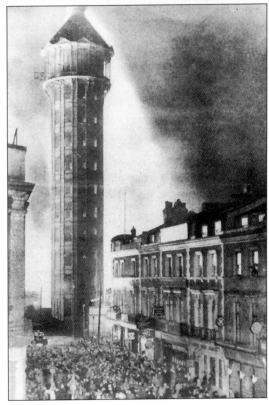

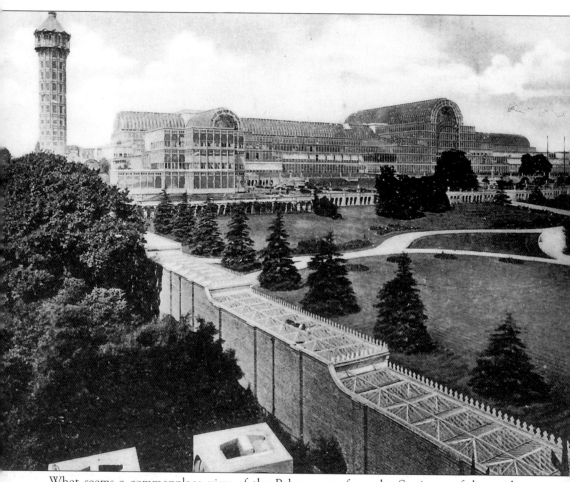

What seems a commonplace view of the Palace, seen from the Station roof, but with one exception. What on earth are the two large square objects shown down below on the left? Space capsules? Discarded washing machines? Or are they, perhaps, much closer to the camera? Your guess is as good as mine. The answer appears when we look closely at old photographs of Crystal Palace (Low Level) Station. See, for example, the one reproduced in the author's *Camille Pissarro at Crystal Palace* (1995), page 61. There it can be seen that the tall chimneys on the station building were capped with large cowls, possibly to stop the rain coming in. So the photograph above must have been taken from the flat roof with iron balustrading, which is also visible in the second photograph.

Three

Beulah Spa and Beulah Hill

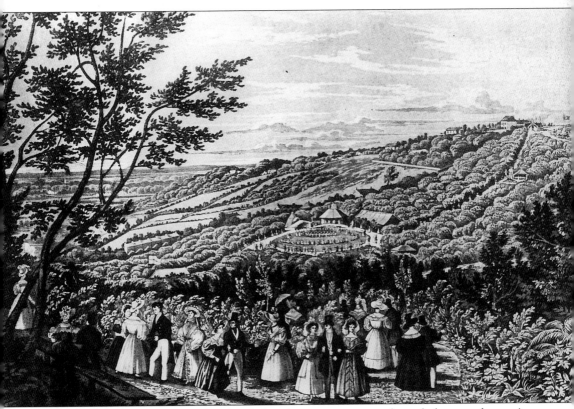

Concentration on the Crystal Palace has led to the comparative neglect of what was the area's major tourist attraction, twenty years before the arrival of the Palace. The Beulah Spa Wells were known throughout the country by the 1830s, and major events were held in the grounds. The present Beulah Spa Hotel at least preserves the memory of the name.

THE BEULAH SALINE SPA, NORWOOD.

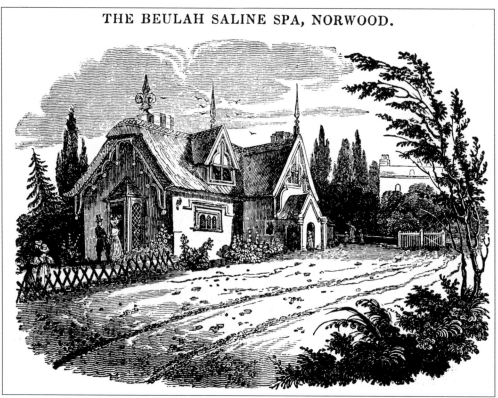

The whole Spa complex was designed by Decimus Burton, who also designed Regents Park Zoo. Tivoli Lodge, the one Burton-designed attraction which survives, stands inside the gateway at the top of Spa Hill. It included all the elements of rusticity, including gables, porticoes, dripstones and elaborate chimneys. The illustration of it dates from 1832.

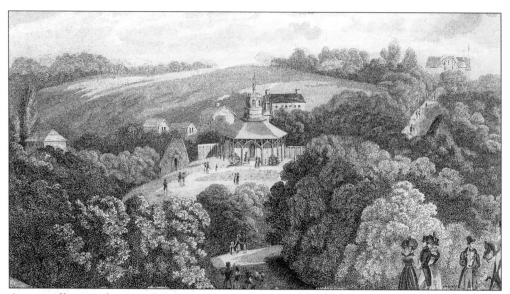

An overall view, showing Tivoli Lodge at the top of the hill on the right, and the pathway leading down to the complex of buildings in a semi-circle below.

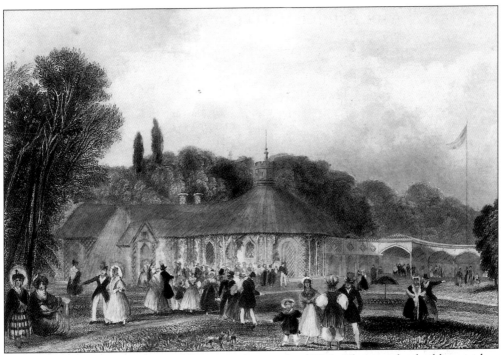

Two further views of the central Spa complex in the 1830s. The circular building with a thatched roof, was a reading and tea-rooms; the Spa building stands to its left. There was also a resident orchestra, rustic bridges, fountains, in fact, many of the facilities later offered in the grounds of the Crystal Palace. No surprise then, that when the Palace opened nearby, the Spa closed within two years. But its site survives as a public park, The Lawns, and the old carriage-way still leads to it through the woods.

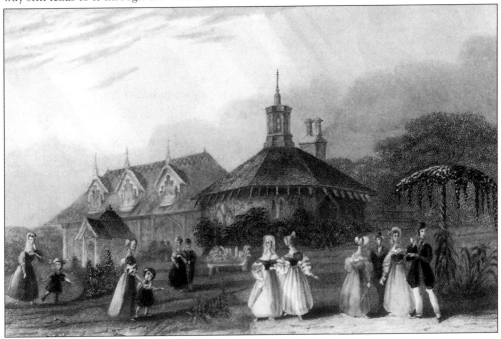

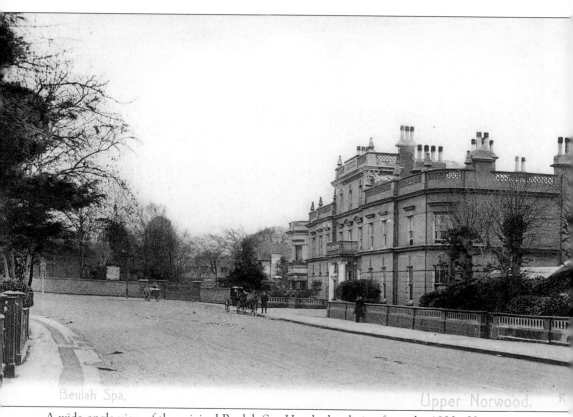

Beulah Spa, Upper Norwood. E

A wide-angle view of the original Beulah Spa Hotel, also dating from the 1830s. Here one sees Tivoli Lodge in the distance, on the right of the old gateway, which also survives. Both the Lodge and the attractive Jacobean-style building opposite it were for sale at the date of this photo, about 1905, but thank goodness were not demolished by the new owner. On the left, the old houses and gardens have been removed and the new housing set well back.

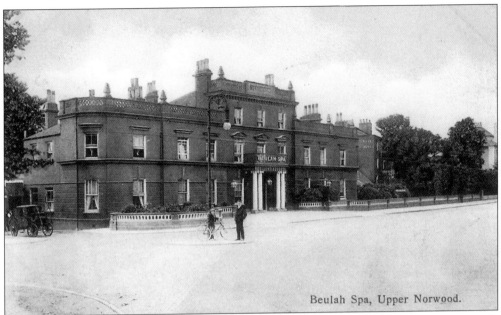

Beulah Spa, Upper Norwood.

Closer views of the original Hotel. Even the exterior views show a building of great interest. It was demolished by the brewers, and replaced by a building of less historical interest. At least in 1995 it was still called the Beulah Spa, and had a plaque recording its completion in 1939. Now the dead hand of a restaurant chain has hit it: both the original name and the date have been removed. As that chain has seen fit to abolish the name of such an important historic feature of the area, they certainly do not deserve to have their name recorded here!

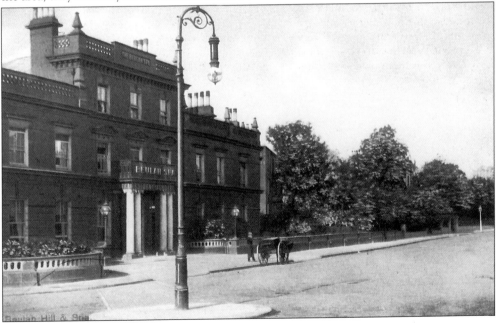

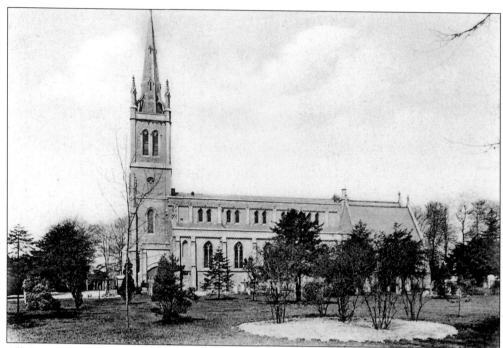

All Saint's Church, at the junction of Beulah Hill and Church Road, was designed by James Savage and opened in 1829. It was the first church in the Norwood area, thus saving people the long walk to Croydon. The tower and steeple were added in 1845. It was still visible from the south when this photo was taken: the card was issued in about 1900, but since then, growth of trees has obscured it completely from this point.

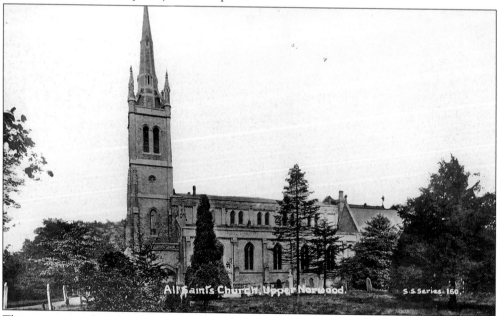

This view must date from 10-20 years later, as the trees have grown considerably, and more tombstones appeared. But the trees in the first view all seem very young, making one wonder if that photograph dates from the 1860s or 70s, and was later turned into a postcard view.

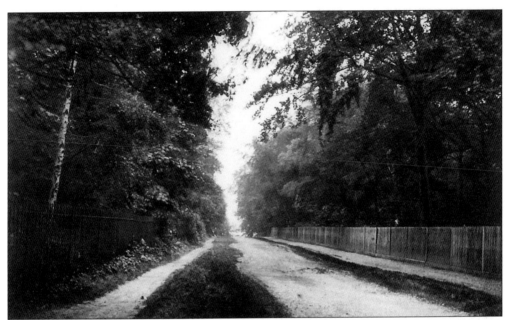

Wharncliffe Road runs along one side of Grangewood Park, though now housing fills the other side. Emile Zola also took a photo almost identical to this: presumably the scene attracted them because it still appeared so rural, although it was just down the road from the busy Triangle. The park railings are on the left in this view of c. 1920, while the woodland on the right was soon to be removed for housing.

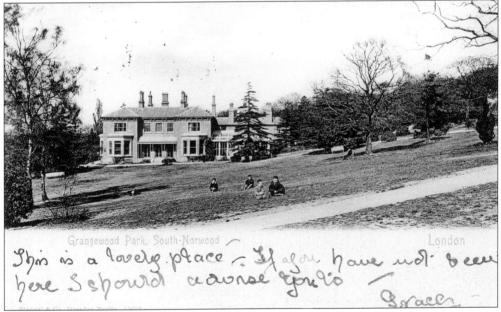

Grangewood Park, South-Norwood — London

This is a lovely place — If you have not been here I should advise you to —

Brace —

So great were the charms of Grangewood Park, according to the Edwardians, that the composite cards of both Upper and South Norwood claimed it for themselves, while one postcard also attributed it to Thornton Heath! Overlooking Grange Road, just off Beulah Hill, the views from the Park over to Croydon must have been magnificent, before the housing was put along the west side of Grange Road.

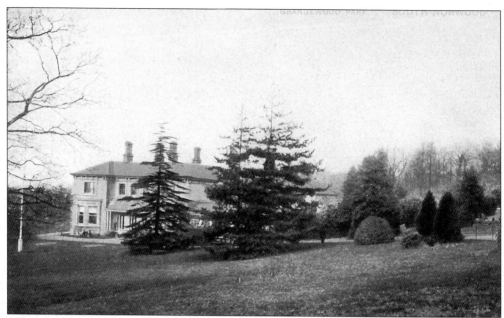

The two main attractions in the Park were the Mansion and the Lake. The upper view is of the Mansion in about 1900; the other may be about 1910. One card describes the house as a Museum; Croydon published a catalogue of its collections in 1910. The house was destroyed by Croydon Council in the 1950s, and only its foundations have been kept, as a curious memorial.

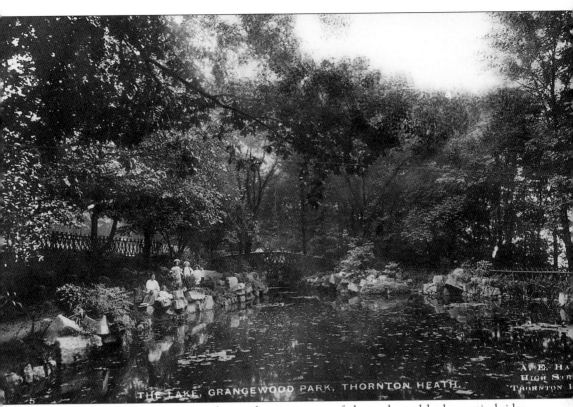

THE LAKE, GRANGEWOOD PARK, THORNTON HEATH.

The ornamental lake stood near the south-west corner of the park, and had a rustic bridge across one end, which seems to feature in all the postcard views of the lake: this card was posted in 1915. The lake was filled in in the 1960s: no doubt to simplify maintenance. But some of the rustic stones can still be seen around the oval-shaped site of the lake.

CHURCH ROAD, AND THE DATING OF POSTCARDS

Postcards became immensely popular in about 1905, and any postcard reproduced in this book is likely to date from around then, unless stated otherwise. But that date only gives us the latest date of the image: the photograph might be much earlier. We have already seen this in the two postcards produced in the early 1900s (page 14), showing a feature of the Palace destroyed in 1866. The two postcards opposite, of Church Road, can serve as a demonstration of both the possibilities, and pitfalls, of dating a postcard. They are taken from almost the same spot, as shown by the pillared gatepost with its gas lamp, in the centre of both pictures. However, the lower picture is likely to be later: by the time of this picture, a metal container for holding grit for the roads has been installed on the left, as has a man-hole cover behind it. More especially, the simple gas lamp posts have been replaced by taller, more elaborate curving ones. There is likely to be at least ten years between the two scenes, and as the lower one was posted in 1920, one could guess the other was about 1905, when postcards had become immensely popular. Both dates turn out to be wrong. The lower picture also exists as postcard with an "undivided back". This dates from the time when the post office, after banning postcards for decades, finally allowed them to be posted, for a halfpenny postage instead of the penny letter-post. But to avoid everyone sending detailed messages, yet giving the post office only half its previous revenue, they decided only to permit cards which had just the name and address and a stamp on one side, leaving the entire message to be squeezed on whatever bit of white space was left, on the same side as the picture. Such restrictions proved quite effective, and this situation lasted from 1900 till about 1903, when the "divided back" was allowed. This now meant that a detailed message could be written on half of the back, the name and address on the other half, and the picture could now take up the whole of the other side of the card. It was this combination of a full picture, and detailed message, sent at only half the cost of a letter, which led to the absolute explosion of postcard sending from 1903 onwards. The lower picture of Church Road exists in the early form, with an "undivided back", of 1900-1903, so the photo itself must have been taken before 1903. That means that the upper image probably dates back at least to 1890, even if not turned into a postcard until, say, 1905.

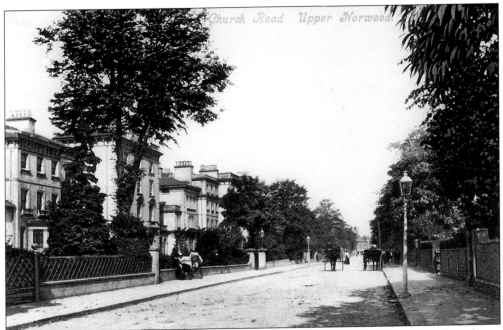

Church Road is one of the three roads, with Westow Hill and Westow Street, which make up the triangle of roads at Crystal Palace. Church Road continues well outside the triangle, leading almost a mile south to All Saints Church on Beulah Hill.

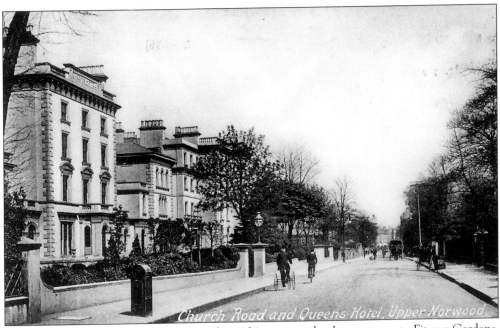

The white pillar at left, at the corner of no 124, now marks the entrance to Fitzroy Gardens, commemorating the residence of Captain Fitzroy, Captain of Darwin's ship "The Beagle". Fitzroy was the inventor of meteorology, and has an appropriate tomb in All Saints Churchyard.

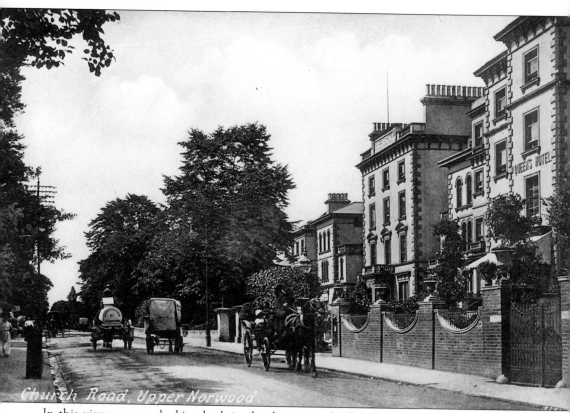

Church Road, Upper Norwood.

In this view we were looking back in the direction of All Saints' Church, with the Queens Hotel on the right. After 150 years, the Queens Hotel was renamed the Quality Hotel in 1999, but the old name survives in the plasterwork on one of its buildings. The hotel opened in 1854 and received distinguished guests as far back as 1861. In 1898 Emile Zola came to stay there. He had fled to England after writing "J'accuse" in the Dreyfus case. He was himself accused of slandering the French government, and sentenced to imprisonment in his absence. He found Weybridge too far off from the big city. Norwood was closer, but he could still live anonymously there. In splendidly civilised fashion, his wife stayed with him in the hotel, while his mistress stayed a few doors away. Zola was here for a year, and took over a hundred photographs of the surrounding area. Most are reproduced in *Emile Zola, Photographer in Norwood*, published in 1997 by the Norwood Society. A plaque commemorating his stay was placed on the Hotel in 1990. In this photo, the house at right "The Tyrol" was later removed to make room for the post-War hotel extension. Note also the cart with its round barrel: this was actually an oil-carrier, for oil lamps, and this one is carefully labelled Corporation of Croydon.

Four

Upper Norwood The Crystal Palace Triangle

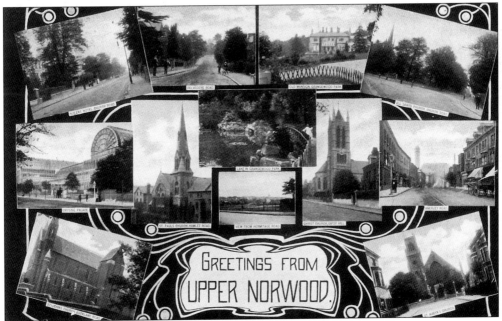

Composite cards like these give a very good idea of what the Edwardians thought were the main attractions of an area. This one was posted in 1907. Such cards were normally produced by pasting up on a board a selection of local postcards, and then photographing them as a whole. But only one of these pictures is a postcard shape, so it is more likely this card was produced using twelve original photographs. This very fine composite (the original is skilfully coloured as well) was produced by the Chaucer Postcard Co. of 62 Chaucer Road, Herne Hill. Among the features shown here are the Crystal Palace, the Queens Hotel, no less than five churches (three have now gone), including St. John's Church, Auckland Road, at bottom left, and the view up Anerley Hill to the Palace.

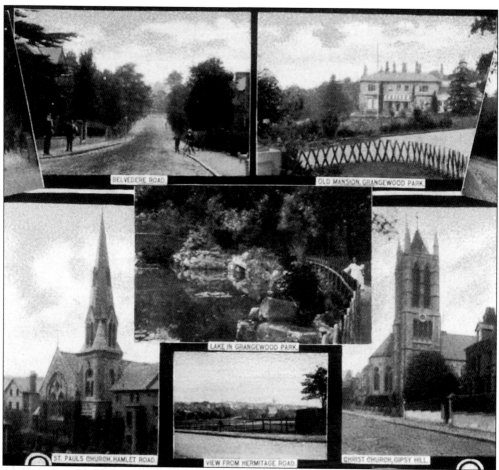

A closer view of the central pictures of the composite postcard. Belvedere Road (top left), which leads down from Church Road, has changed little, and the two houses just visible at the bottom of the slope, are still visible from this point in winter. They lie on either corner of Anerley Grove, and each has on its roof, a square room with windows on all four sides. These provided a "splendid view" or "belvedere" for the owners and their guests, and so gave their name to the road. Top right and centre are two attractive views of the house and lake in Grangewood Park. St. Paul's Church, bottom left, is seen at a different angle from our other picture of Hamlet Road. The view from Hermitage Road, at its junction with Eversley Road, is no longer across green fields, but the equally green Norwood Recreation Ground. The White Hart, shown on the opposite page, was renamed O'Neill's in 1997, despite the fact that the pub dates back at least to the 1860s.

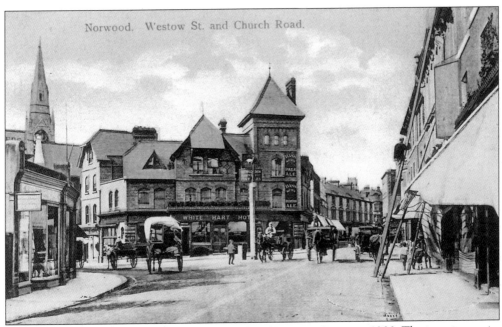

The White Hart, at the corner of Church Road and Westow Street, c. 1900. The inn-sign on its post has gone, but the old-fashioned Victorian-type lighting outside is quite effective. At left, some attractive single-storey shops which lasted until 1987, when all except two were replaced by an office building. Above them, the spire of the Greek Orthodox Church.

The single-storey shops, as seen in January 1985, just before demolition.

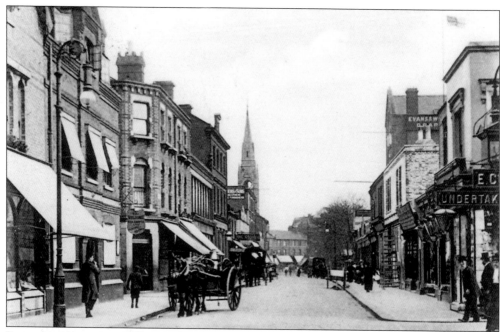

From this viewpoint in Westow Street, looking down towards the White Hart in about 1900, there is little change on the left, with the same Greek church at the end. The most pleasing change is the addition of a Victorian clock to the gabled building at left, now the Foresters Hall, beside Childs Lane. Cullens the undertakers have moved to Church Road and beyond them, all is changed.

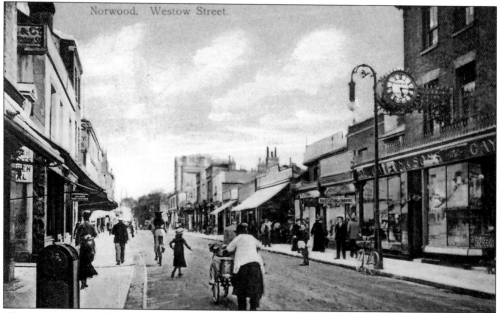

The other side of Westow Street. This shows us the original position of the clock: thank goodness it was not simply scrapped. Three of the single-storey shops have been replaced by a larger building, but those on either side of it have lasted. In the distance, the tall building, a piano warehouse, was removed in the 1980s for a superstore.

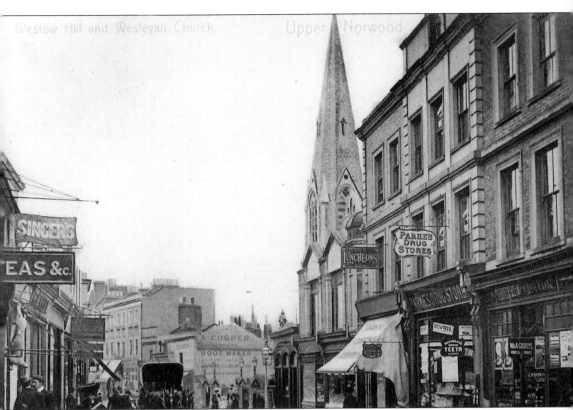

Westow Hill, looking west towards Gipsy Hill. Upper Norwood Library is just out of the picture to the right. All the shop buildings on the right survive, down to the former gateposts in front of the Church. In the photo, Parkes drug stores have a restaurant on the left and an off-licence on the right. The three arches of the Queens Arms Hotel have not changed, though the sculpture of the Arms on top has gone. However, the name of the Queens Arms was changed in 1997 to the Orange Kipper. Can anyone seriously regard this name as an improvement?

The Methodist Church was built in 1875 and lasted until 1963, when it was demolished and replaced by a new structure at the back: the forecourt now becoming shops. (An excellent historical description and old photograph inside the Church entrance sets a good example which other replacement churches could well adopt.) On the left, those looking at the side wall of the then tea shop can spot its early origin, with lovely old chimneys of what must be an old cottage.

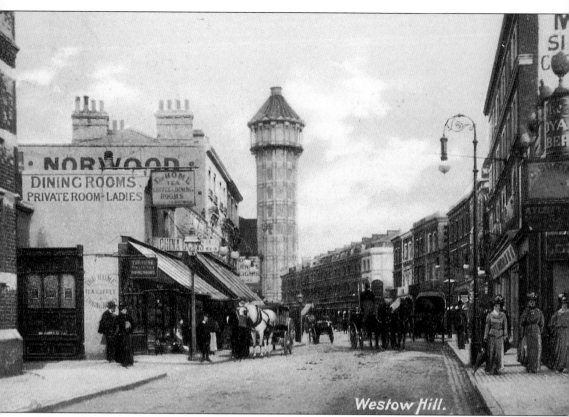

Weslow Hill.

From the same spot as the last picture, but in the opposite direction, looking east. The view is dominated by the South Tower of the Palace, on Anerley Hill. At far left, the corner of Upper Norwood Library (built 1899) next to Beardell Street. At right, cobbles still lead into the yard of the Royal Albert pub. But two new buildings replace the Home Dining Rooms. In the 1960s, this was an antiques shop, with a fine range of Crystal Palace memorabilia. Woolworths had a serious fire in about 1990, and was completely rebuilt. For a good view of the scene in the 1960s, see page 63 of "Crystal Palace - Norwood Heights" with illustrations by Audrey Hammond and text by Brian Dann. This is the best book for the more recent history of the Crystal Palace Triangle.

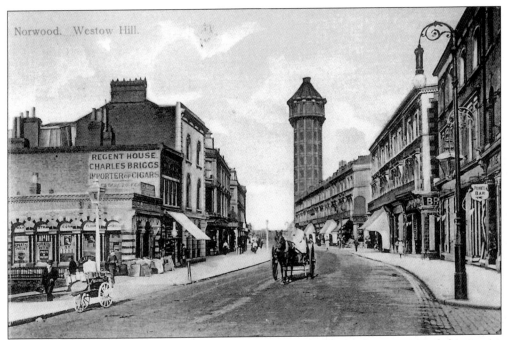

Two similar views, from slightly further along Westow Hill. The lower postcard, having an "undivided back" dates from around 1900. But the view above looks distinctly earlier: the scene is less busy, and the traffic more rustic: probably from about 1890. (We found similar dates for two pictures of Church Road, earlier.)

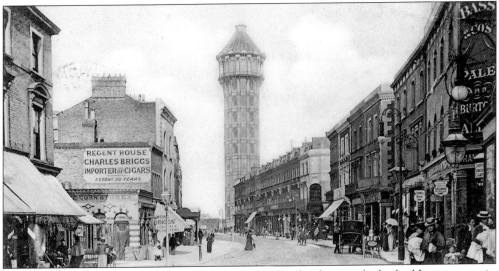

Charles Briggs' cigar house is now part of Barclays Bank, along with the building next to it, while the single-storey corner shop supplied "Flour, Corn, Hay and Straw", as well as Spratts Patent Food for Dogs. The author can remember seeing potatoes on sale here at 2d a pound in 1956, but all is now replaced by a three-storey discount store. The tavern and shop on the far right are now a builders' merchant and Joanna's restaurant.

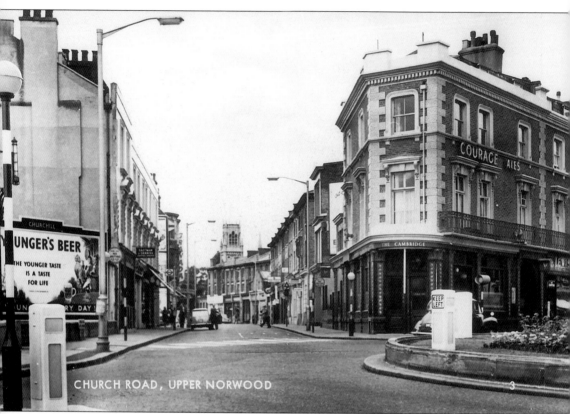

CHURCH ROAD, UPPER NORWOOD

The roundabout at the top of Anerley Hill. This is a highly significant spot: it used to be known as the Vicar's Oak, when an oak stood here to mark the boundary between the four boroughs of Bromley, Croydon, Southwark and Lambeth. (The borough of Lewisham joins at the other end of the Parade.) Such a meeting of boroughs often led to the neglect of Upper Norwood, as everyone felt the area was not their concern. But the creation of the Crystal Palace Triangle Association, and later the Norwood Society, seem to have lessened this trend. All the same, with Bromley's interest in encouraging community spirit, it would be nice if they were to plant a new oak at this important spot. Both views feature the Cambridge tavern. The one above is looking down Church Road, with the square tower of St. Aubyn's Church in the distance. The car, including a Morris Minor, seems to indicate a date about 1960.

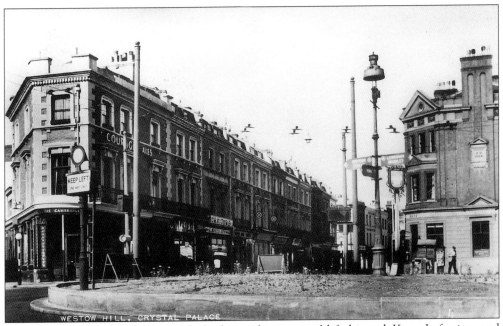

Here, the roundabout has pristine kerbs, and a more old-fashioned Keep Left sign and vintage gas lamp too: so the view probably dates from about 1950. A far smaller roundabout now leaves room for juggernauts - but still has a few flowers in the centre. On the right, the former National Westminster Bank recorded its completion in 1884. It replaced the dairy where Camille Pissarro, the French Impressionist, stayed in 1870/71. His stay is commemorated by a blue plaque on the building, and the name Pissarro House given to it in 1998, after the bank sold it.

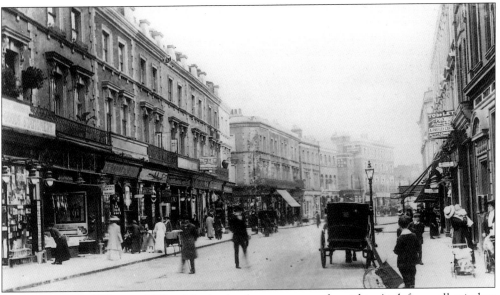

A closer view of Westow Hill, with the bank entrance at far right. At left, small window balconies have replaced the generous iron balconies. The first three shops at left are a stationers, butcher and off-licence.

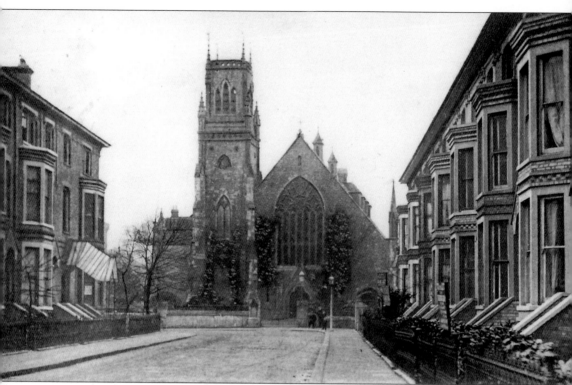

St. Aubyn's Church dominated the area inside the Triangle, from its completion in the 1860s till its demolition in the 1970s. Church Housing Association flats now stand on part of the site. The buildigh which replaced the church, the old URC hall, is now the Celestial Church of Christ. All the houses on the right have gone, but those on the left survive, and this postcard was actually written by a holidaymaker from Hastings, who was staying at no 22 when she wrote it. The iron railings survive beside nos 30 and 31. None of the railings on this side would have been removed during the War, as people might otherwise have fallen down into the forecourt during the blackout. What is worrying is that the owners have been allowed to remove the bay windows in several of the properties, including both sides of no 32 on the corner. The new brickwork makes this even more obvious. Do not such removals spoil the entire character of the house, both in itself and as part of a terrace? Thankfully, this is now part of a conservation area, so such drastic alterations should not be permitted in future.

Five

Lost Railways at the Palace

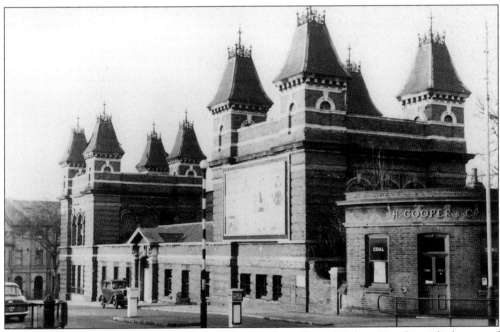

Above, the High Level Station in the 1950s, seen from Crystal Palace Parade, with the top of Farquhar Road at left. This station adjoined the Parade, and was part of the High Level Line which ran from the Palace to Nunhead between 1865 and 1954. Because it ran through Dulwich, it had quite elaborate Gothic-style stations on its route, designed by Charles Barry Junior, who was architect to the Dulwich Estates Governors, and also designed Dulwich College. The High Level Line was a rival to the Low Level line, but this really resulted in both lines running at a loss. On 19th September 1954 a special steam train marked the last journey, and the line was removed soon after. The High Level Station building was not demolished until 1961, but now housing stands on its site. The present Crystal Palace Station is from the Low Level line.

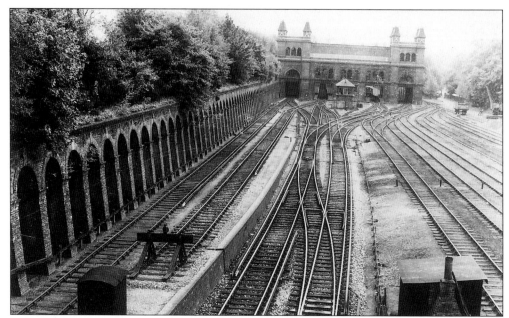

Looking from the College Road end towards the Station in 1954. The Parade is on the left, and this line of arches survives beside it. Under the Parade itself still lies an elaborately constructed subway, which led from the Station straight into the Palace. It is occasionally opened for the public.

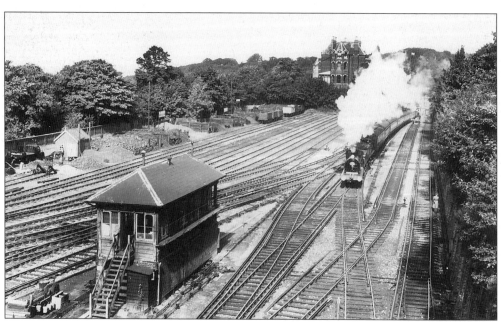

Looking from the Station in the opposite direction in 1954. In the distance, a splendid private house later demolished after subsidence. Coming towards the viewer is the last steam train to travel on the line, on 19th September 1954.

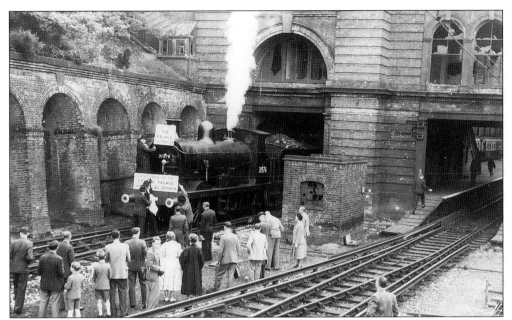

Laying a wreath on 'The Palace Centenarian', so-called because the first Crystal Palace Station (Low Level) had opened in 1854, 100 years earlier. The author and his younger brother are on the left, wearing short trousers.

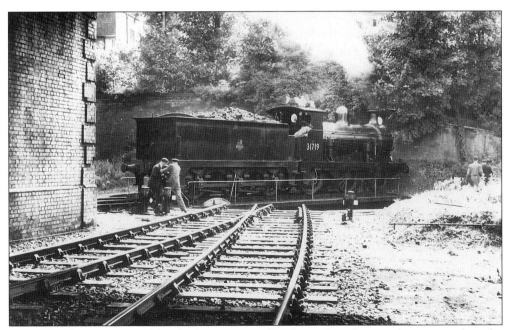

Two steam locos were used for the last journey: this shows the other one being turned on the turntable, which stood just the other side of Farquhar Road bridge from the Station: an area now used for parking.

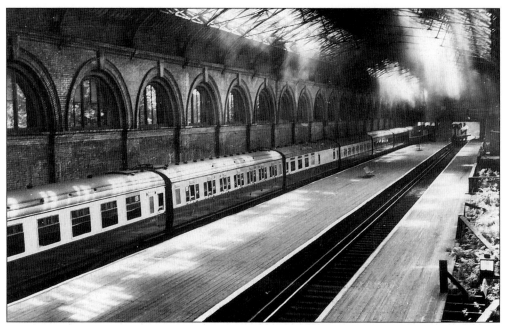

The last train inside one half of the High Level Station: this platform was still in reasonable repair.

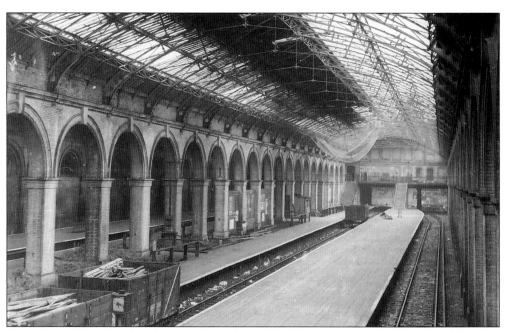

Some idea of the dilapidated state of the other half of the interior on the last day of use. It is ironic that in 1995 the Crystal Palace (Low Level) Station, despite remaining in use, has now been allowed to reach a similar state of decay.

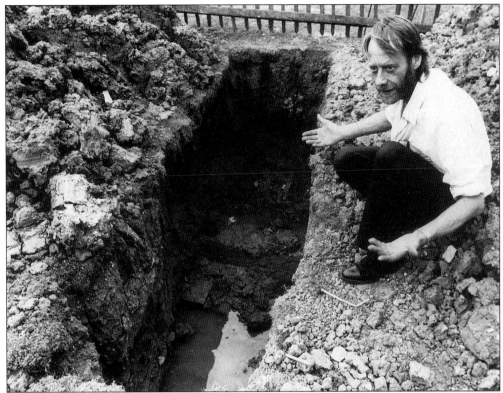

The subway which still runs underneath Crystal Palace Parade should not be confused with the experimental underground railway which ran through the Palace grounds for two months in 1864. It was built on a highly unusual principle, whereby the entire train was blown through the tunnel. The carriage had a set of brushes which touched the tunnel wall, and a gigantic blower pushed air through the tunnel, and the train with it. The return journey was made by reversing the fans, and sucking the train back. It ran apparently very successfully for two months, and took large numbers of passengers. There must be personal accounts of such a trip in diaries or letters of 1864, though none has yet been discovered. But the tunnel was then removed without trace, in accordance with the agreement. We know it ran some 600 yards between the Sydenham and Penge entrances, and included a curve and a steep slope. But it was only in 1989 that its course was discovered by the Marquis de St. Empire. Only one photograph of his trench was published: in the Comet Leader newspaper of 30th August 1989. The photo was taken in the fenced area near the One O'Clock Club beside the Sydenham entrance. The complete photograph, reproduced here for the first time, shows the butt end of one wooden rail, in front at left, and a dark depression where a second rail ran, next to it. The Marquis never published his results, and seems since to have disappeared without trace. But the photograph is proof of his findings. There has long been a myth that the train, packed with passengers in Victorian costume, still lies hidden deep in the Park, where they were buried. Exciting though the story is, there is no account of any such disaster in the Park, and it is hard to believe the Press could have failed to report it at the time.

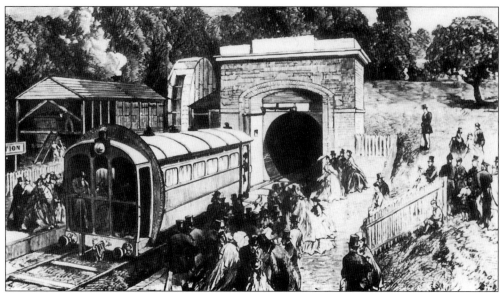

The only known pictures of the underground railway in the Palace grounds. Though from a similar viewpoint, they seem to have been drawn independently, and show different details of the workings. This is the first time they have been reproduced together.

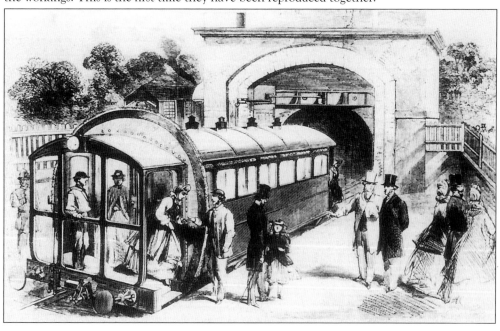

Six

Upper Norwood
Outside the Triangle

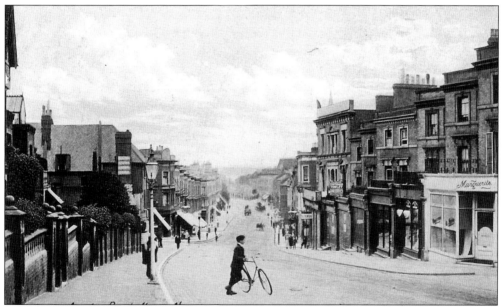

Anerley Road runs into the distance, though here we are looking from Anerley Hill, halfway down it, with the corner of Pleydell Avenue on the right. The shops are still there, though Marguerite's ?Fashions is now an off-licence. By contrast, all the houses and gateposts on the left have gone, as the result of bombing, though a pleasant garden was built on part of the land by Bromley Council in about 1990. Many of the railings on the shop balconies have been retained. Were they originally put there to give a view of important visitors coming to the Palace?

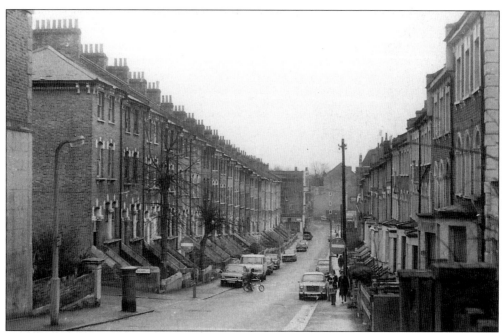

Four views of Palace Road, now completely replaced by a modern housing estate. These photos, taken in 1977 just before demolition, give an idea of the sort of housing which could easily have been renovated, but which Bromley Council thought it simpler to remove and replace. The first photo looks down the hill towards the Paxton Arms and Anerley Hill at the end.

A closer view of the terrace seen complete on the left of the first picture. The replacement housing is not unattractive, but was built when there was still a general presumption against the retention of Victorian houses.

The view from near the top of the hill, with part of Palace Square on the left. A small part of the Square was retained, with some quite fine buildings.

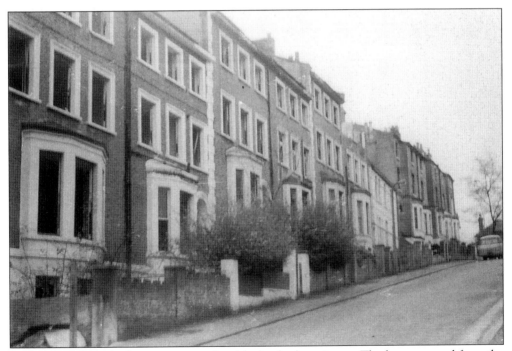

Looking uphill at the houses seen on the right in the last picture. The house second from the left is the one in which Pissarro had lodgings for the last half of his stay in 1871, after leaving Westow Hill.

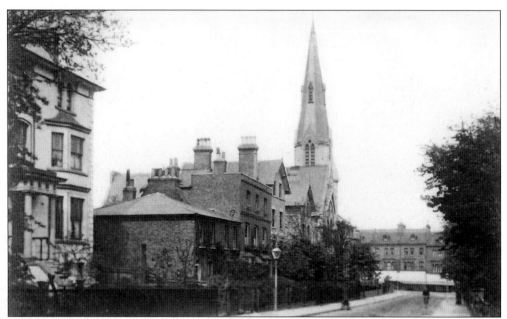

Looking along Hamlet Road towards Anerley Road. St. Paul's Church was replaced by a modern building in 1973, as evidenced by stonework preserved beside the entrance. But all the other houses, and the shops beyond in Anerley Road, are still there. When visited, the old two-storey cottages on the left, nos 12 and 14, had quite magnificent flowering front gardens, which really gave a lift to the area. Perhaps other residents could be persuaded to do the same?

AUCKLAND ROAD, UPPER NORWOOD.

Looking along Auckland Road in about 1905, from its junction with Hamlet Road. The spires of St. John's Church, Sylvan Road, are just visible. On the right, the green at the bottom of Fox Hill is now shorn of its railings, which went in the War. But the two main trees on the green, one with a kink, the other multi- branched, are quite recognisable. The house on the corner has even kept its wooden fence.

Fox Hill: a drawing published in 1893, showing the reverse to Pissarro's view, when he produced the painting now in the National Gallery. The same wide house with its two chimneys is seen in both pictures. On the left, the brick wall of no 15, the Tudor-style house after which Tudor Road gets its name. In the distance is the entrance to Palace Grove, and the two spires far away would have been the Congregational Church in Anerley Road, and Holy Trinity, Croydon Road: both now gone. When first built in the 1870s, Auckland Road did not join Hamlet Road, but instead came out in Fox Hill, at what is now Fox Hill Gardens.

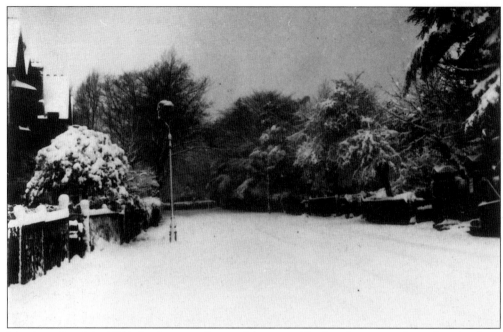

Mowbray Road in 1954. Looking up the road from no 12, this shows, on the right, the front garden fences of the odd-numbered houses on the north side. All were replaced in the 1960s by a modern estate, except for no 1.

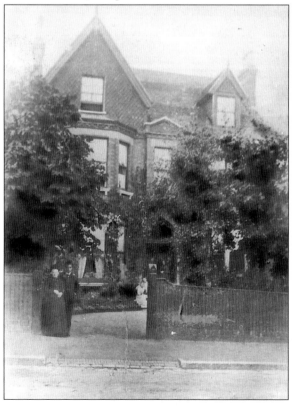

No 11 Mowbray Road in about 1890. This was the home of the Bensusan family from 1876 to 1956, and it was to here that Camille Pissarro came back in 1892, to gain permission for his eldest son Lucien to marry Esther Bensusan. The couple married in Richmond later that year.

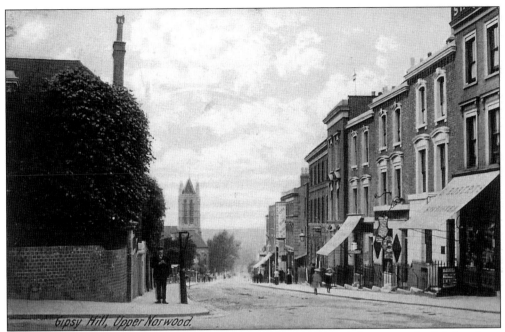

Looking down Gipsy Hill from Westow Hill, the former doctor's house on the left has been replaced by modern flats. The four shops on the right can be identified as Roberts Stationers, an office, Griffiths cycles, and a barber's shop, with its barber's pole. In 1995 these had become computer sales, an office, opticians and a private house.

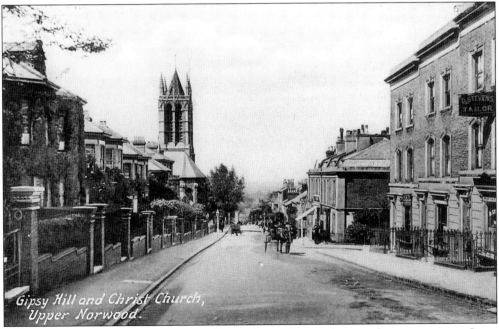

Much of this is delightfully unchanged: only the traffic prevents one from enjoying it. Some ornamentation has been lost from the houses on the right, but the tailor's shop, now a private house, has retained it. One should pity the single horse toiling up the hill!

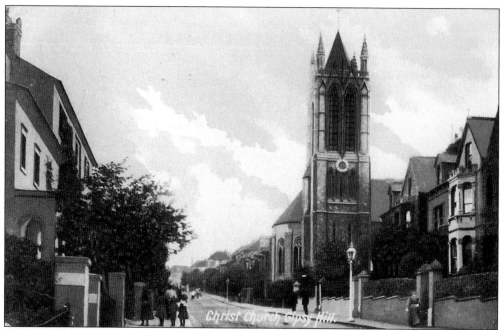

Looking up the hill, we see Christ Church, Gipsy Hill. This was consecrated in 1867, on a site which faced new housing on the east side of the hill. It was one of those many churches afflicted by arson, in 1982, but the tower has been kept, and still serves as an attractive and important landmark in the Hill. In 1995 it was converted to a private house. On the left, the fine porchway of no 64 shows that all these houses are original.

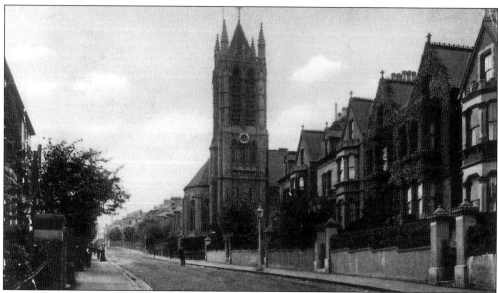

The houses on the right, nos 23-29, have some of the finest architectural carving and decoration on private houses to be seen anywhere in Norwood. Unfortunately, the carving is in sandstone, and it is a moot point how long it will survive under the onslaught of acid rain. Only two of the nine indented gate capitals survive. The modern equivalent of these houses can be judged by no 31 beside them: a pale shadow of what must have stood here before.

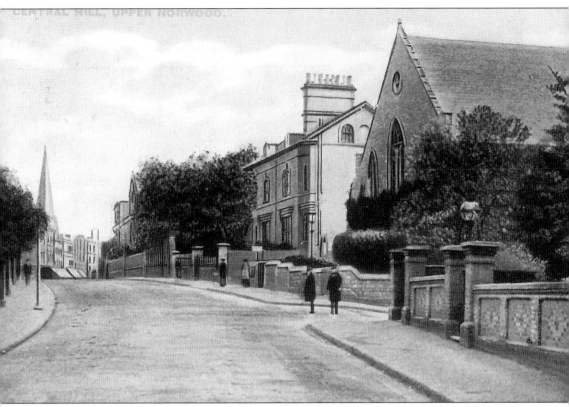

Looking up Central Hill towards the junction with Westow Street, nothing remains of the two large buildings in the centre of this picture. The large church on the corner of Gatestone Road was the Central Hill Baptist Church. They stood on the corner of Gatestone Road, and are now replaced by the flats of Gatestone Court. The finely patterned wall on the right remains, but minus its decoration. The gateposts on the corner are original, but the two straddling the main entrance have been rebuilt, with new capstones, and without the elegant glass lamp. For many years in the 1950s to 70s, this was the surgery of Mr Martin the dentist. The spire in the distance is the Wesleyan Methodist Church in Westow Hill. One puzzle: why are the two distinctively dressed gentlemen standing in the middle of Gatestone Road?

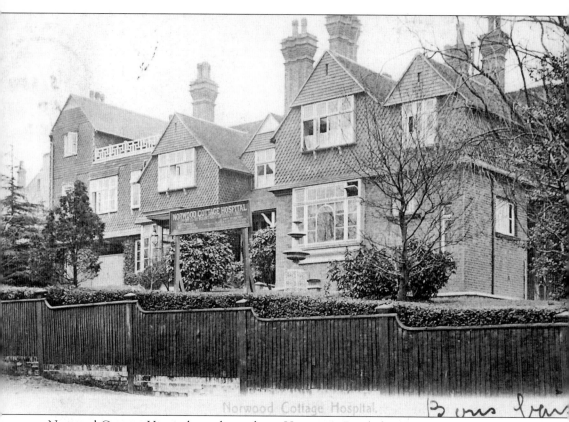

Norwood Cottage Hospital stood just down Hermitage Road, from its junction with Central Hill, and was opened in 1882. Ten years earlier, even the Road was just a hedgeline between two fields! For many years in the twentieth century, the road was not made up, and fields stretched on both sides all the way to Beulah Hill. The third field along held the cows for French's Dairy, of Gipsy Hill. Cottage hospitals were immensely useful in relieving distress among those too poor to pay for medical care at home. The notice says that it was "supported by voluntary contributions", and gives underneath the details of the Secretary and Treasurer. Such hospitals were abolished, when it was decided that bigger automatically means better. But the building itself has been retained (without the balcony at left), and is now Canterbury House, a home for handicapped people.

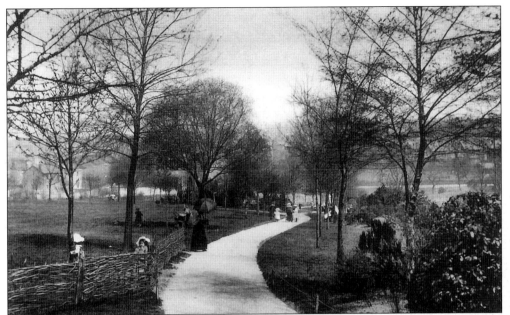

Upper Norwood Recreation Ground, at the bottom of Harold and Hermitage Roads, was created when it became obvious that the surrounding streets would soon be covered in housing. Our first picture was taken from the entrance in Eversley Road. Most of the trees in this photo appear to have survived a century of growth. But the view on the left has now acquired tennis courts.

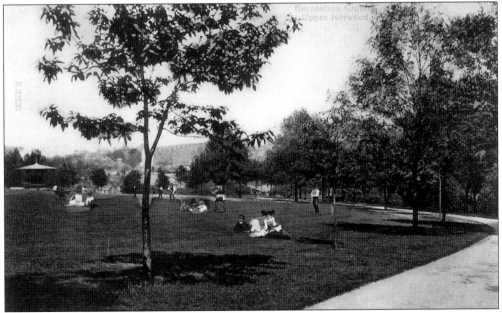

A short distance down the path from the earlier picture, the two chestnut trees on the curve of the path are still there, but not the bandstand on the left, the site of which is now marked by a clump of trees. On the extreme left is the gable of St. Margaret's Church, and the roofs of houses in Rockmount Road rise in the distance. As well as the children and nannies, the two groundsmen pose for the photographer, with broom and shears.

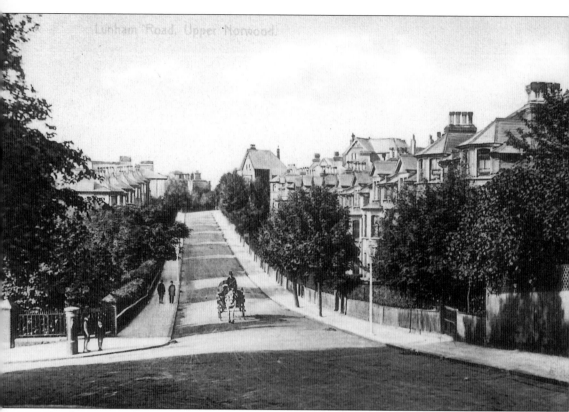

Looking up Lunham Road from its junction with Hawke Road, we now see the appalling effect of this type of municipal housing on a formerly attractive Victorian road. True: all the houses visible on the left are still there. But every house on the right has been demolished, to be replaced by faceless blocks, graffiti-encrusted, and dominated by two tall grey chimneys - ideal for a crematorium - in slabbed concrete in the worst traditions of the South Bank. The trees do little to improve matters. At bottom left, the pillar box, iron railings and fine brick pillars might easily have been retained. But no, the juggernaut was unrestrained. Let us hope some lessons have been learnt from this. While I observed the scene, a passing schoolgirl said to her friend, "I was in Woolworths, while my mate was shoplifting at C&A's." Could there be a better example of the influence of the environment on those who live there?

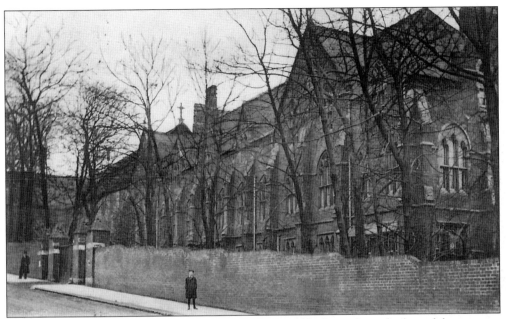

Virgo Fidelis School for Girls, Central Hill, in about 1905. Apart from the loss of the cross on the roof, the front entrance has scarcely changed. But it is no longer used as a vehicle entrance: that is lower down, away from the bend of the hill. A light-controlled pedestrian crossing now also assists the pupils.

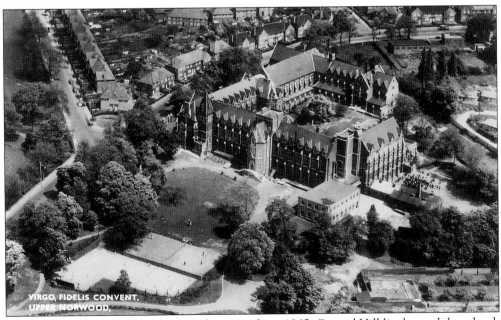

A fine view of the School taken from the air in about 1965. Central Hill lies beyond the school, with Salters Hill joining it top left.

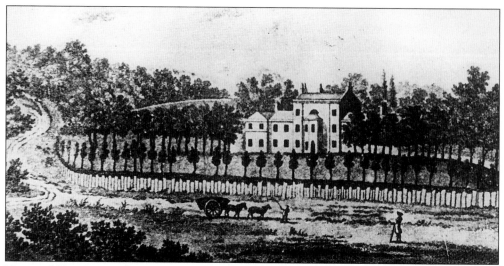

Norwood House, now the Junior School of the Convent, as it appeared in the 18th century. It no doubt got its name by being the grandest house in Norwood at the time. In 1779 it was left to a Mrs Nesbitt, who had close connections with the government. As a result, during the reign of George III, several Privy Council meetings were held in its ballroom, which is preserved in the house.

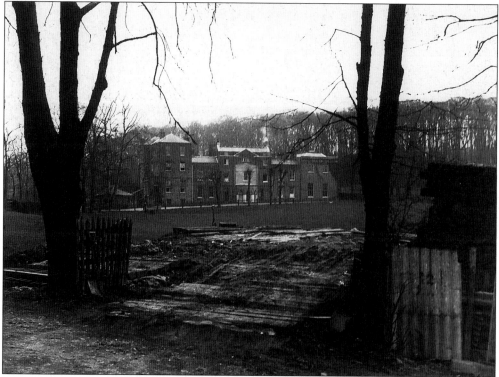

Norwood House in 1935, after it had been turned into a hotel, and then the Junior School. It can been seen through the gates of the school, at the vehicle entrance opposite Elder Road. Virgo Fidelis School itself was established in 1857, partly to help Irish orphans from the Irish Potato Famine of 1847. Its chapel building was added in 1871.

West Norwood

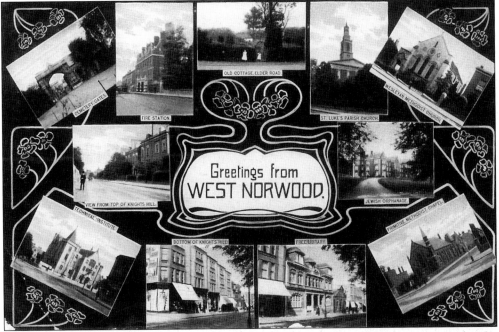

The feature which put West Norwood on the map, and still dominates the streets around, is St. Luke's Church, dating from 1822. The suburb became even better known once West Norwood Cemetery opened in 1837. Both features appear in this composite card, posted in 1907. In fact, of the eleven places featured, more than half still exist, and four are now listed as of historic importance. Seven of them are described in more detail below, but we may start with St. Luke's Church. This was completed in 1822, as one of the four so-called Waterloo churches named after the four evangelists. Though limited to a north-south site, the powers that be insisted on an east-facing altar, which meant that it had to be placed in the middle of the east side wall! Designed by Francis Bedford, it was rearranged and partially redesigned by the equally distinguished G.E. Street.

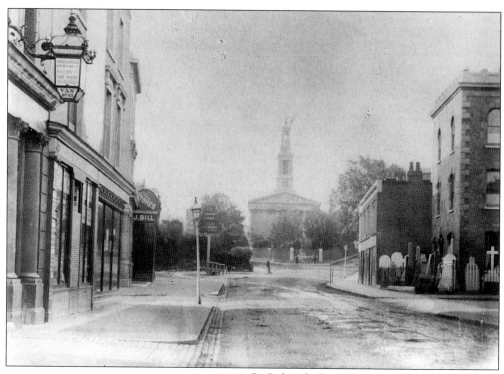

St. Luke's looking south, in about 1870. On the right, the building with gravestones in what had been its front garden, was now owned by William Jackson, stonemason for the cemetery. In the 1870s one of his lodgers was Alfred Pissarro, brother of the Impressionist Camille Pissarro.

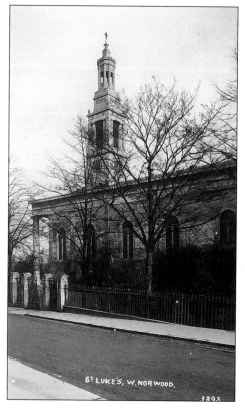

A close-up side view of St. Luke's from about 1905. The stone pillars survive along this side in Knights Hill, but the iron railings and gates have gone (apart from one iron pillar to the south). They were presumably taken for scrap during the war, and replaced by wire netting. Yet, in this view, all three trees survive!

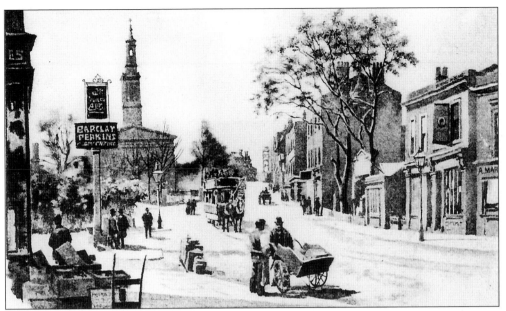

A drawing from about 1890, with the Thurlow Arms again prominent on the left of the picture. By now the tethering-post for horses has been removed from outside the pub. Lord Thurlow was a major landowner in the 18th century.

This photo, apparently dating from the 1920s, continues the view to the right of the upper picture on page 84. But the stonemason's yard has now become a shop front, at the corner of Lansdowne Hill. The poster says "Labour gets things done": a slogan repeated in much more recent campaigns. Woolworths now stands on the site, and the site on its left, shops which were bombed during the war, had new buildings put up in 1993.

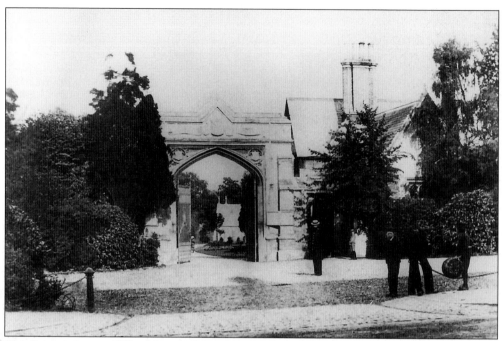

The front entrance of West Norwood Cemetery in about 1880. The archway, dating from 1837, is part of the original design by Sir William Tite. The cemetery rapidly became the most fashionable in South London: hence its title of The South Metropolitan Cemetery.

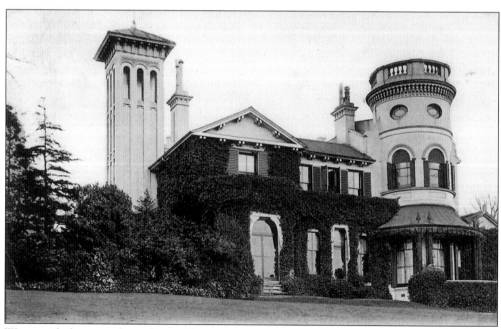

Westwood: the magnificent home of Charles Haddon Spurgeon, Baptist preacher and the Billy Graham of his day. His funeral in 1892 was the largest ever at Norwood. Westwood stood off Beulah Hill where Spurgeon Avenue is now, and Spurgeon Road was its driveway.

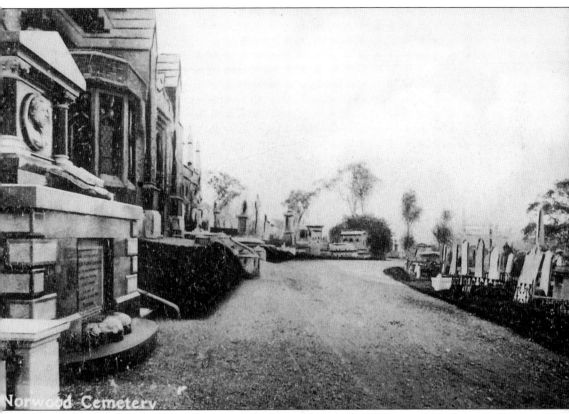

Norwood Cemetery

An unusual postcard view showing inside West Norwood Cemetery. Posted in 1910, it shows Spurgeon's tomb on the left, beside a corner of the Johnson memorial (the inventor of Bovril). In the distance, the tombs of Mr Hill (founder of Higgs and Hill) and Mr Edgar (from Swan and Edgar). The Cemetery has 64 listed tombs: more than twice as many as any other cemetery in the country. Most of the tombstones seen on the right were cleared later by the Council, and the Dissenters' Chapel, visible behind the Spurgeon tomb, was damaged during the war, and replaced by the present crematorium. This postcard was sent by a young visiting French boy to his English teacher in Paris. It starts, "My dear Miss, In England we can't find enywhere some Bufflo Bill. Everybody is in black for the King" (i.e. in mourning for the death of Edward VII).

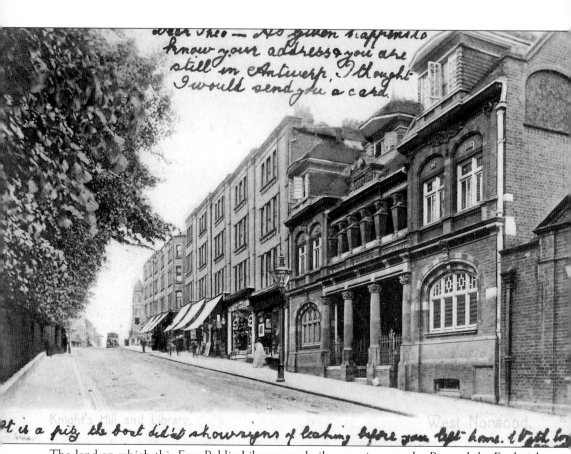

Knight's Hill and Library, *West Norwood.*

The land on which this Free Public Library was built, was given to the Borough by Frederick Nettlefold in 1887. It was designed by Sidney Smith and built by Higgs and Hill, as recorded on the foundation stone at bottom right. Seven fine portrait busts, all named underneath, give the Victorian view of famous writers, from Homer to Dickens. A new library was built nearby in the 1950s, though preserving Nettlefold's name. The building was listed Grade II in 1993, at the author's suggestion. Let us hope that protects it, as Lambeth, the owners, announced in mid-1995 that they would no longer occupy it. Frederick Nettlefold himself was one of the distinguished Lambeth residents buried in West Norwood Cemetery: the Council destroyed his tomb in the 1970s. This card was sent in 1906 to a sailor aboard the ship `Yola' in Antwerp. The sender adds the thought-provoking postscript, "It is a pity the boat didn't show signs of leaking before you left home."

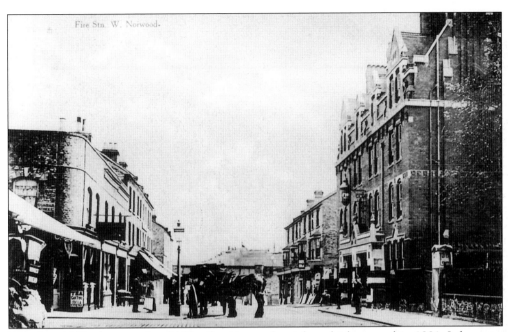

Posted in 1908, showing the old Fire Station on the right, which opened in 1881. It has now been converted into the South London Theatre Centre, and is listed Grade II. At left, there is still a grocers on the corner of Dunbar Street, but the remaining row of shops has gone. The shops on the right have also survived.

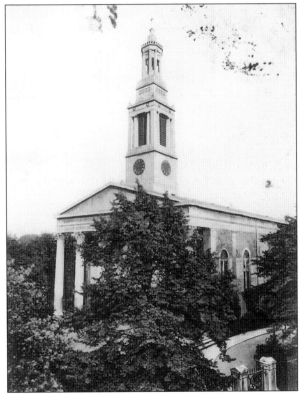

This entrance to St. Luke's, seen from near the old Library, does not survive. All except one of these stone pillars were removed when a large piece of the churchyard was removed for (what else?) more space for cars to drive round it.

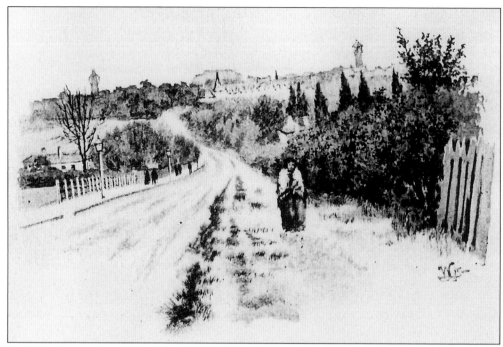

In 1890 this was the delightful rural scene from halfway down Crown Hill (now Crown Dale), with the two Crystal Palace towers in the distance. The spires of the Fidelis Convent are visible in the middle, and at left can be seen one of the cottages shown below.

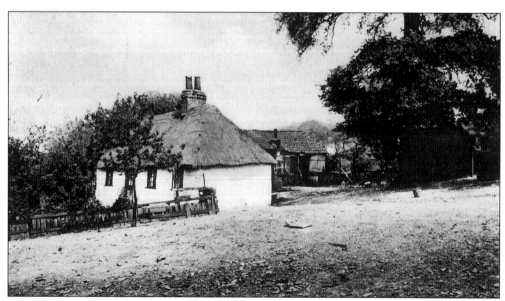

One of the three thatched cottages which still stood in 1900 in what became Norwood Park, near the junction of Elder Road and Central Hill. The creators of the new park demolished two cottages but kept the third: sadly, this was destroyed by bombing during the war.

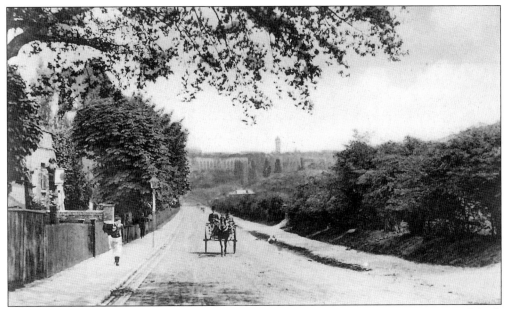

A similar view of 1900, from higher up Crown Hill. Houses and housing estates now fill both sides of the road, and replace the fields and hedgerows on the right. Yet it is possible that the tree overhanging the photographer then, is the same magnificent chestnut tree which stands halfway down, near the entrance to the estate.

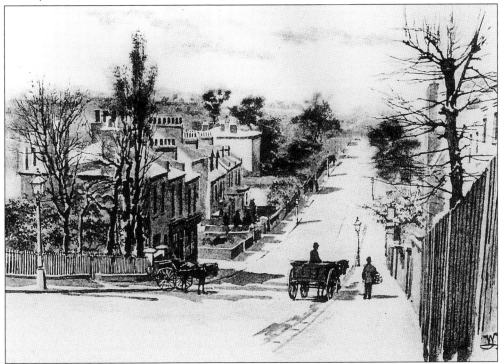

Gipsy Road in 1890, looking down towards Elder Road. An interesting contrast between the right-hand side, which is quite unchanged, and the left, where every house and shop has been replaced by blocks of flats.

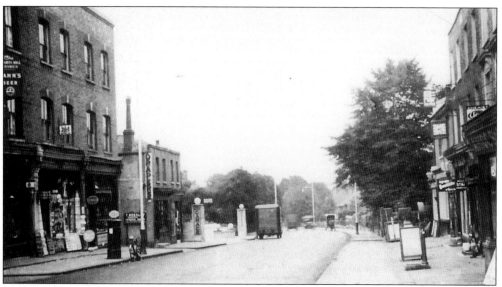

Crown Point in about 1920. Only the set of three shops on the left enable us to locate this view, looking from the top of Knights Hill, with Edge Point Close just out of sight on the left. A new garage replaces the old one on the same site. The right-hand side has been completely rebuilt, but set well back from the road, leaving room for a triangular green at this point. A good idea in theory; unfortunately, the volume of traffic totally precludes its enjoyment.

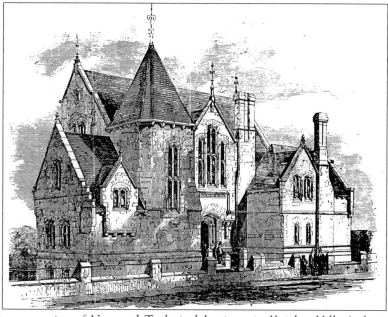

A Victorian engraving of Norwood Technical Institute in Knights Hill. Arthur Anderson, founder of the P&O shipping line, gave the money for it in 1859. He lived at Norwood Grove (later occupied by Frederick Nettlefold), and was buried in Norwood Cemetery. The Institute was like an early polytechnic, and is now funded centrally. During the Second War, the College became a wireless training college and a secret laboratory for evaluating captured enemy wireless equipment. These premises were demolished in the 1980s, and the modern buildings of the College stand further down the Hill.

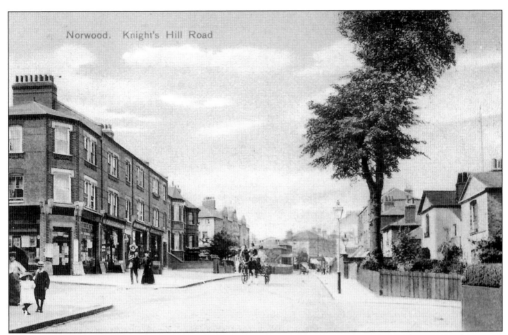

Knights Hill Road: a card posted in 1906. Though hard to recognise, the only major change is that the gardens on the right now display a line of cars in front of a dealer's showrooms. We are actually at the junction with Thornlaw Road on the left, and Ernest Avenue (with its bus station) on the right. Almost every building is still there.

Thornlaw Road in about 1890, at the junction with Casewick Road. The very fine tile-hung house nos 4 and 6, with its covered way, is still there on that corner, and the `twin peaks' on nos 17-19 are there too. But Ernest Avenue, at the bottom, has industrial units instead of the row of houses. The ladders must be for pollarding the plane trees.

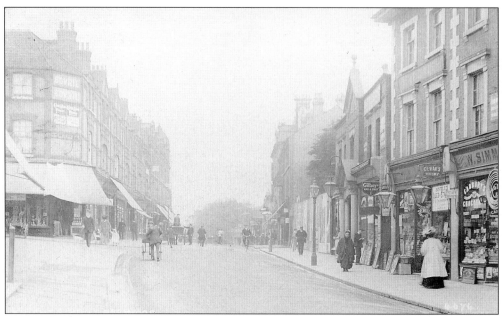

The shops in Knights Hill, with Wolfington Road on the left: a card sent in 1911. The shop on the far right is still a confectioners, and still next to an off-licence: a remarkable continuity of trade. In the picture, the sweet-shop's windows are plastered with adverts for Cadbury's chocolate, but they also advertise "Picture Postcards". Next door advertises Dewar's whisky and Gilbey's spirits.

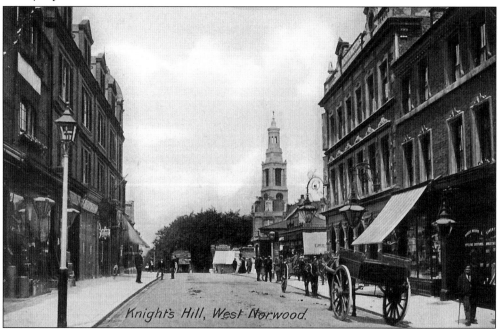

Moving closer to the Church, the Norwood Hotel is still on the corner of Cotswold Street with the old West Norwood Station beyond. The building next to it (far right) has gone. The placing of a neat series of large iron bollards along both sides of the road here has finally stopped cars parking illegally on the pavement. They now park illegally on the road.

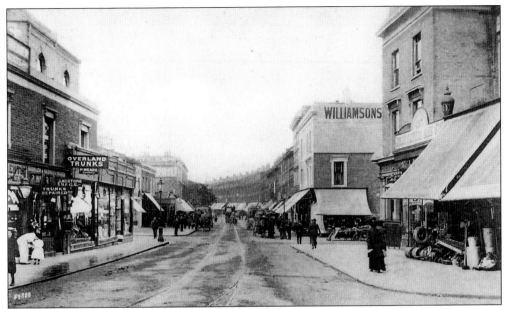

Looking north from the front of St. Luke's. On the right, only one shop building has gone: a branch of Williamson's. The Thurlow Arms is just out of sight. But on the left, the store selling Gladstone bags was bombed, and the site only built on again in about 1990.

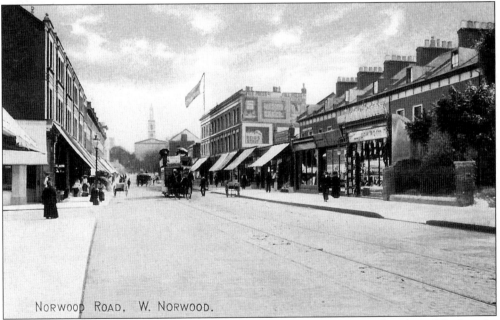

NORWOOD ROAD, W. NORWOOD.

Little change in the scene, in that every building has survived, except for where Woolworths has replaced the tall building to the right of St. Luke's. The change comes immediately to the right, as shown by the next photo, looking in the opposite direction, possibly taken by the same photographer. Note the tram rails for the horse tram.

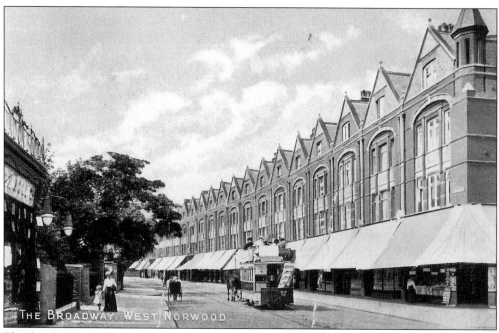

The thundering traffic discourages one from looking up to see that the Broadway survives complete, stretching between Chatsworth Way and Lancaster Avenue. All that is missing is the conical spire on the brick turret at this end. But on the left, the presence of trees impedes one from recognising this as the site of a modern DIY store. The horse-tram adds a nice period feel.

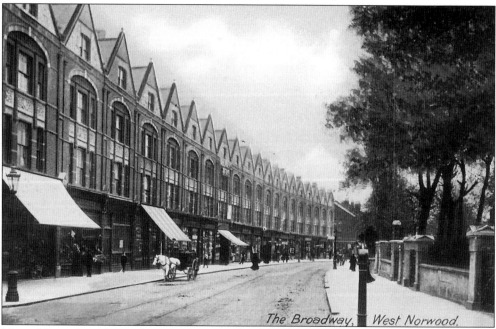

Viewed from the other end, at the corner of York Hill. This time even the conical spire and ironwork survive. But the gateposts and long front gardens with trees have now been replaced by a DIY store, a petrol station and a Co-op shop. Some of the Broadway frontages have elaborate white plaster decoration, as seen at top left.

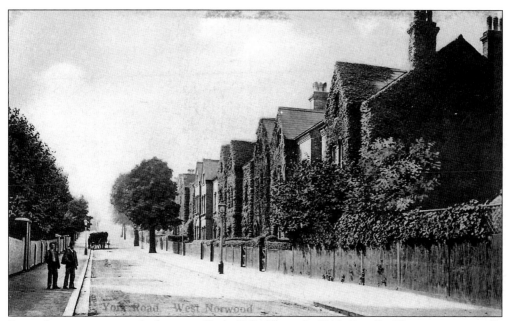

From the same corner, looking up York Hill (formerly York Road). The scene is totally unrecognisable, as a rocket hit the lower part of the Hill, and demolished virtually everything in sight. There are fifteen other York Roads in modern London: renaming this one York Hill did not just recognise the steep hill: it also made the road-name unique.

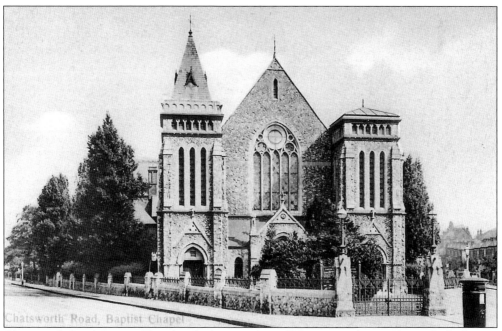

Chatsworth Road Baptist Church, which opened in 1877, seen in about 1900, with the houses of Idmiston Road visible at right. So rural were the surroundings when the church was built, that in 1878 they had to shoo a cow away from the front door before they could start the Sunday morning service! The Church was destroyed by a V2 rocket, and a new church replaced it.

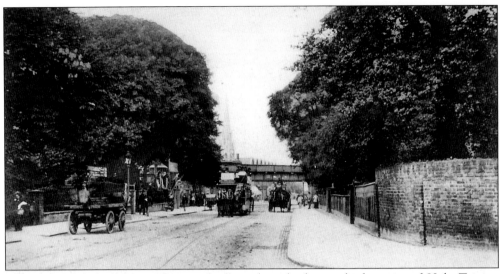

Norwood Road, looking north towards the railway bridge, with the spire of Holy Trinity, Trinity Rise, in the distance. But with those exceptions, the scene is virtually unrecognisable. We are standing just beside the present fire station (and former tram depot) of West Norwood. Large blocks of flats have replaced the brick wall and front gardens at right, while shops have appeared on the left.

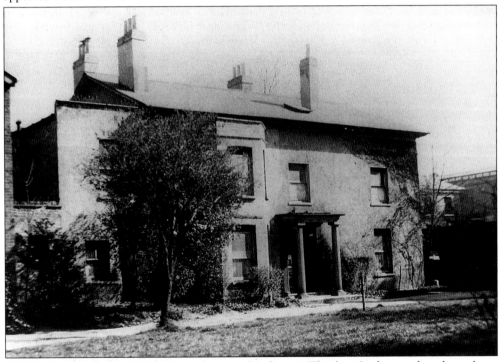

Hidden behind the front wall at right was this house: Thurlow Lodge, said to have been occupied by Lord Thurlow in the late 1700s, when he was Lord Chancellor. A century later, Sir Hiram Maxim lived here: the inventor of the Maxim gun, from which he made his fortune. His "flying machine" installed at Crystal Palace was first tried out in the garden here. Maxim was buried in Norwood Cemetery in 1916: his descendants still tend the grave.

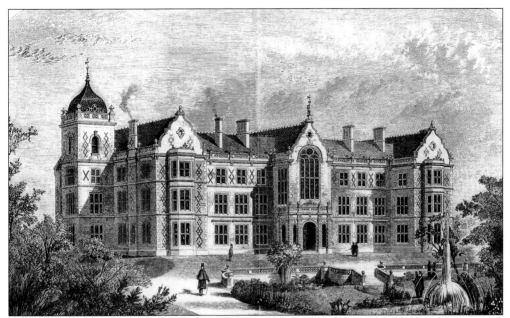

This magnificent building stood just off a sideroad opposite West Norwood Station. It was built for the Jewish School or Jews' Hospital, which moved from Mile End to Norwood in 1862, largely to provide education for Jewish orphans. The illustration of 1862 shows it was in a magnificent mock-Jacobean style. This can best be judged by the Lodge to it, which survives in the approach road off Knights Hill, opposite Cotswold Street.

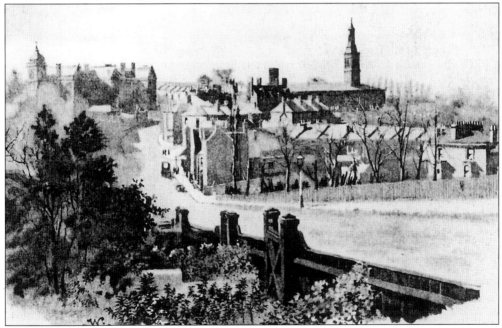

The view back from Auckland Hill towards West Norwood in 1890. As well as St. Luke's on the right, we also see the Jews Hospital in the distance at left. It was demolished by Lambeth Council in the 50s. But the pointed tower with its ironwork pinnacle at far left is still there above the shops, on the corner of the Hospital approach road.

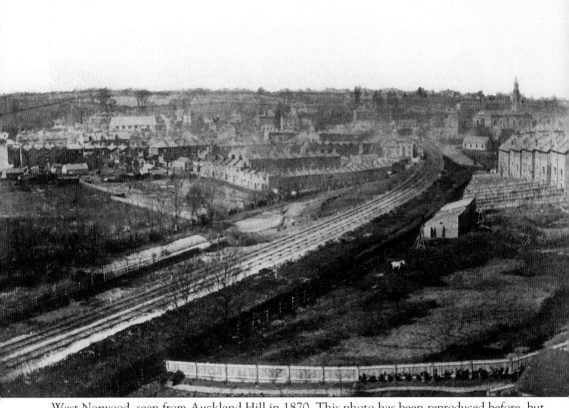

West Norwood, seen from Auckland Hill in 1870. This photo has been reproduced before, but it has not been realised that it is one of a series of four photographs all taken from the top of two neighbouring houses in 1870. A careful inspection of the viewpoints shows that these houses must have been nos 21 and 41 Auckland Hill. This is a panoramic view of West Norwood, from the back of no 21. Though the lower part of Auckland Hill already has its houses, the one large field with a horse was later to be supplanted by the remaining back gardens of houses further up the hill. In the distance on the right, the spire of St. Luke's Church, about to undergo renovation from 1870 to 1872. During those years, a temporary iron church was used: this stood at the corner of Knights Hill and St. Julian's Farm Road, and can be seen on the left of the photograph as the long white building. Behind it, simply farmland.

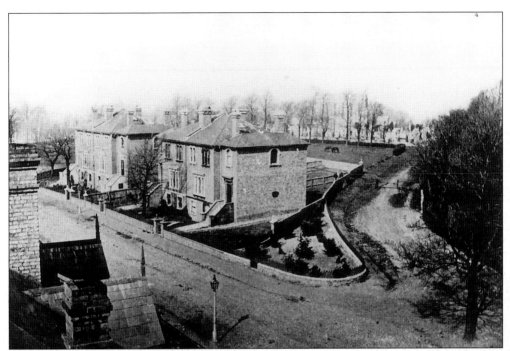

One of two views from 41 Auckland Hill. It features nos 22 to 24 opposite, when they still had stone balls on the gateposts. (26-28 on the left has now gone.) The curving Hubbard Road leads towards what was then one of the cemetery entrances, now blocked. A fence halfway along prevented the horses from straying. Behind the trees, the Anglican Chapel in the Cemetery, designed in imitation of Kings College Chapel at Cambridge, but demolished in 1960.

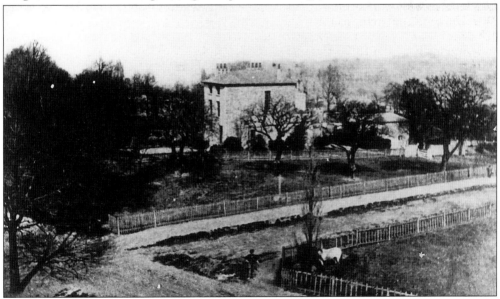

A view which joins to the right of the last one, having the same tree in the centre of the road. This looks over St. Cloud Road, without any houses, but looking across to Durban Road, in which two houses appear. The small one on the right may be the present no 79, which is not quite square with the road.

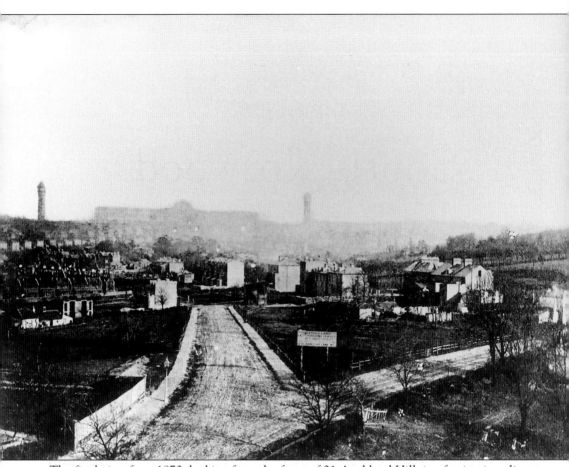

The final view from 1870, looking from the front of 21 Auckland Hill, is a fascinating glimpse of the steady growth taking place in these suburbs, overlooked by the Crystal Palace. We are looking down St. Louis Road, again without a single house, and with Auckland Hill ending at Gipsy Road at far right. The intersection advertises building leases on freehold land. As it happens, a very similar notice appeared on the once-again-empty site in 1990: new building has now appeared on this corner. On the far left are two small cottages. One of these survives, tucked away well back from the frontage of St. Louis Road. The line of tall white houses halfway up the hill at left, seems to be the grand houses of Farquhar Road. Farquhar Road is named after Thomas Farquhar, the first Secretary of the Crystal Palace Company, which ran the Crystal Palace itself. He has a fine tomb in West Norwood Cemetery. This whole series of photos taken from the roofs of two brand-new houses may well have been taken by a developer who was aware of how this and other scenes were changing so quickly.

Eight
South Norwood

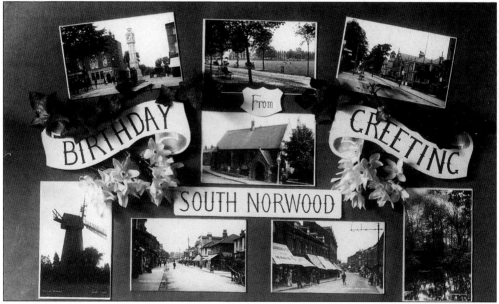

South Norwood owes its main expansion to the presence of the railway station, which originally stood beside Portland Road, before being shifted and renamed Norwood Junction. The postcard manufacturers must have had some difficulty deciding what South Norwood is best known for: perhaps with reason. But it's nice to find that seven of the eight features selected do survive (the exception being the lake in Grangewood Park). In this composite card from about 1910, we see St. Mark's Church, Albert Road, in the centre; the Stanley Memorial Halls and Clock, and views of Portland Road and the High Street, flanked by Grangewood Park and Shirley Windmill. The last-named perhaps stretches things a bit, but Shirley is the next suburb after Woodside, which could be regarded as part of South Norwood. What is remarkable is how little has changed in Portland Road: probably because South Norwood has rather come down in the world during this century, so the money has not been around for major redevelopments.

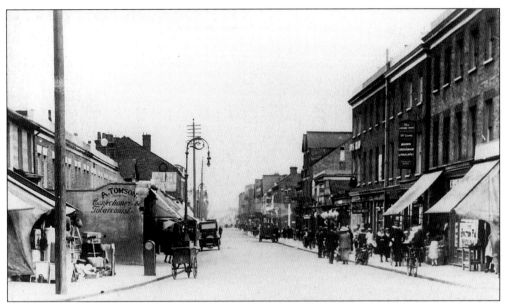

No change in this view of Portland Road from the corner of Albert Road in about 1920. Virtually every building is still there; just the businesses change, such as the confectioner to a barber. Even the lamp-posts, though modernised, are in identical positions.

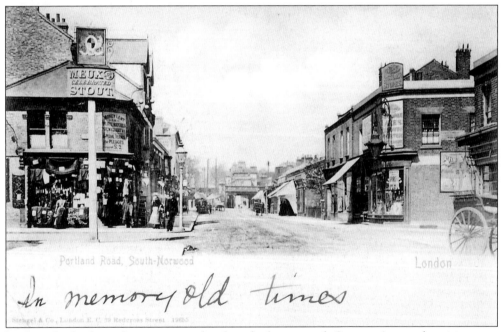

Looking back along the same stretch of road, the original Queens Arms advertising post survives, though it was a nice touch to add a model gun-carriage to the top of the sign. The pawn-brokers on the left is proclaimed by its three balls up above and a detailed display of wares below, along with the offer of "Money lent on plate, watches, jewellery etc.". It is now occupied by an estate agents. However, the Victoria Stores, selling Ales and "Finest Old Spirits: Good Value at 2/- and 2/6d", is still an off-licence.

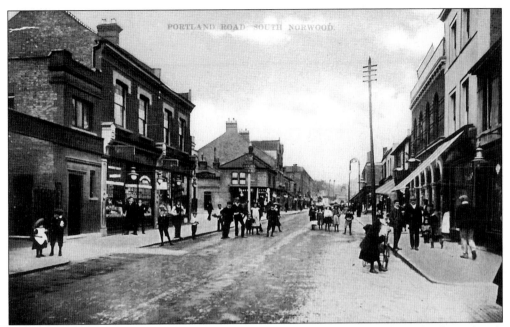

Little change, too, in this view looking north, from near the junction of Portland Road with Crowther and Addison Roads. The Duke of Cambridge still stands on the right; on the left, the simple doorway has now been extended to a larger youth centre. But the heavy traffic makes it dangerous even to stand on the traffic island!

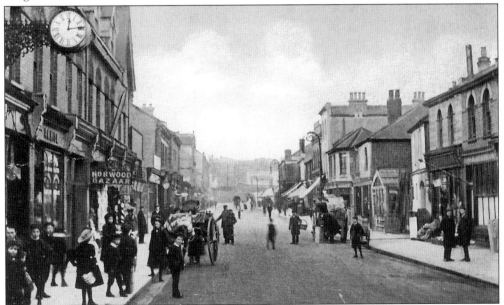

The only casualty on the right is the small greenhouse, though the other side of the adjoining building, a similar gap serves as the entrance to Elizabeth Cottage, an attractive survival back from the road. On the left, Norwood Bazaar has gone, as has the splendid Victorian clock, though the bracket-holes on the wall are evidence of its site. Taken from the corner of Crowther Road: on the opposite corner in 1995, the Red Bar Laundry was still offering a Wash for 2/6d and a Dry for 6d!

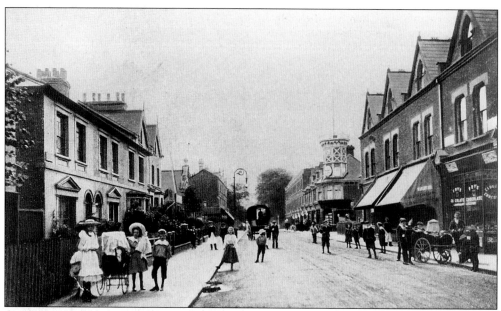

The attractive houses on the left are called Azoff Place and date from 1855, as their cornerstone records. Probably decades earlier than the shops on the right, though those unusually retain their ridge roof tiles. The elaborate mock-Tudor tower is also still there on the corner of Balfour Road, though the strapwork decoration has been painted out, and the flagpole has gone. Further on, the present "Discount Furniture" store, with its flanged dome, had not yet been built: it started as a cinema.

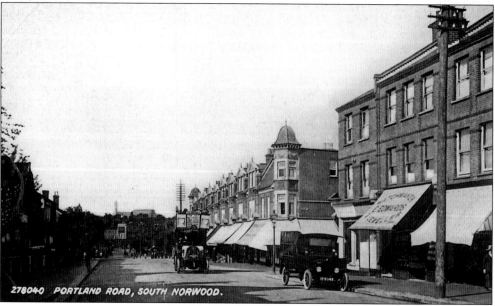

278040 PORTLAND ROAD, SOUTH NORWOOD.

Further down Portland Road, looking back to the north, near the junction with Ferndale Road. The scene no longer has the Palace as its background, but two tall tower blocks. The shops survive (Edwards the jeweller at right is now an off-licence), but what a pity that the nice decorative domes at each end of the shops were removed, no doubt as the cheapest way of repairing the roof.

At the right stands the Church of the Holy Innocents, South Norwood. Next to it is the entrance to South Norwood Recreation Ground in Selhurst Road, flanked by the pillars which came from the entrance to Oliver Grove. They were damaged by a lorry in 1994, but Croydon Council insisted on their complete reinstatement.

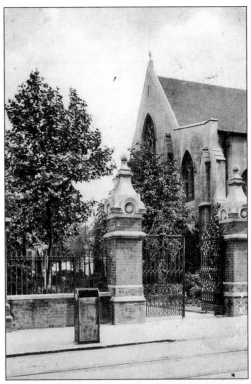

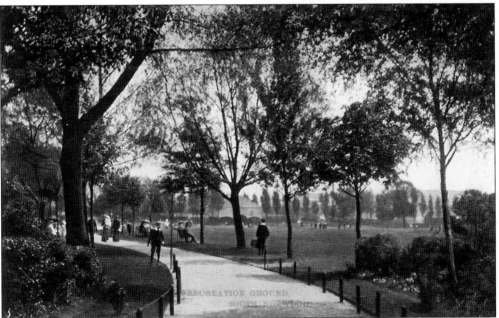

The Recreation Ground, taken a short distance down from the main entrance. What is now the Bowling Ground is on the right, with the row of poplar trees in the distance - some of which survive. This card, posted in 1912, also shows how much more flower planting took place before grassing-over offered a way of reducing maintenance costs. The distinctive many-branched oak in the centre is now flanked by taller trees, but will no doubt outlast them.

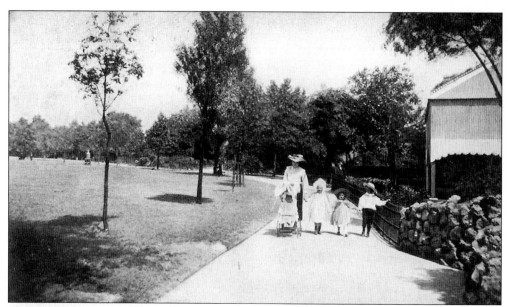

This well-behaved family are all in their finest Edwardian costume. As for the scene, some of the rustic stonework flanking the entrance to the public toilets survives beside the path. But the railings, and roses behind them, have gone, while only the granite base remains of the drinking fountain in the distance. The grand wooden shelter on pillars is now replaced by a mundane hut.

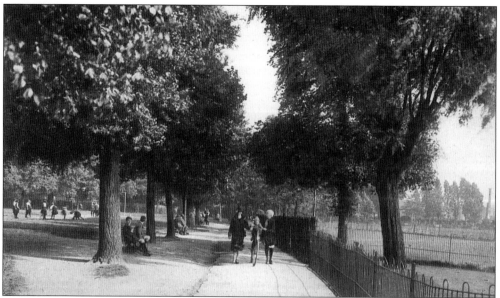

Nothing remains of this grand avenue inside the park, except for the trees on the right. It led from near the entrance in Tennison Road. The railings have gone, and most of the trees on the left were lost in the hurricane of 1987. The entire outlook on the right is now hemmed in by the 1930s houses of Tennison Road - houses not built when this photo was taken in about 1920. On the left, a group of schoolgirls play around the pond which stood in that area. Like so many ponds, this was lost when it was deemed easier to mow grass than to keep it clean. A gain in efficiency is so often a loss to the community.

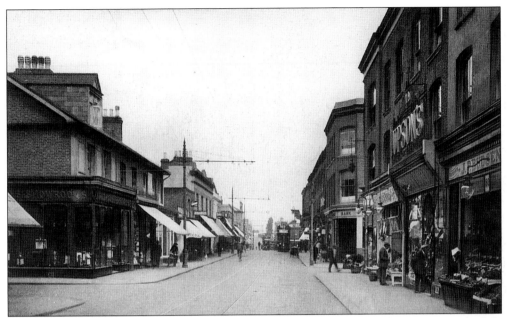

The centre of South Norwood High Street, pictured in the 1920s. The showrooms on the left, at the junction with St. Dunstans Road, are now a building society. The bank on the right, at the junction with Balfour Road, is now an estate agents, while another such agent has replaced Budgen the fruiterers on the extreme right. Once again, every building visible has survived the war. Remarkable that despite South Norwood being both an industrial centre and a major railway junction, Hitler's bombers left both Portland Road and the High Street (except the far end) unscathed.

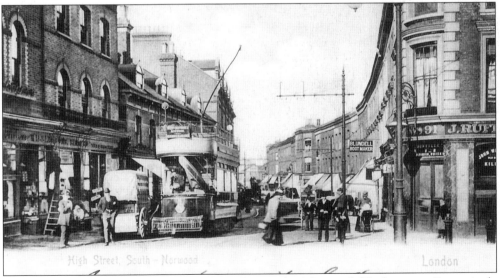

Looking down the High Street, from where the Stanley Memorial Clock is now. Every single building has survived, and most are still shops. But no longer are there tall posts holding the wires for open-topped trams. The covered waggon on the left is delivering Quaker Oats to Williamsons, who were a major chain of grocers: branches in West and Upper Norwood as well. The Alliance pub (right) stands on the corner of Station Road.

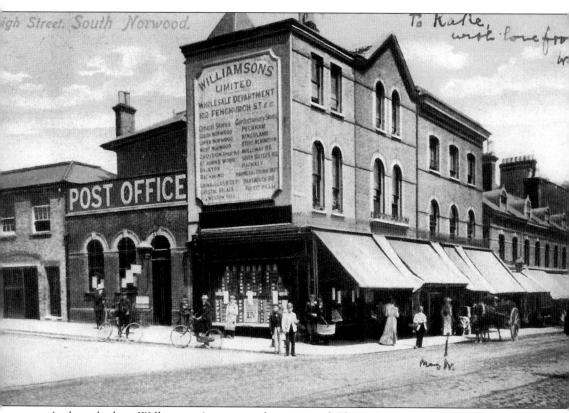

A closer look at Williamsons' store, on the corner of Oliver Grove, with a list of their other branches, mainly in South London. But the interest in this card is its view of the Post Office next to it: the message actually starts: "My dearest Kittie, This is the Post Office where I post your letters. So, when is that letter coming from you, old girl?" It is signed "W.A.W.": most likely her father. Interestingly, he has labelled a figure in the picture as "Mrs W.", who would then be her mother. A close look at this photo shows no less than ten young boys or adolescents standing looking at the camera. It has been suggested that such a picture would have been "carefully posed". I doubt it. Much more likely, the photographer would take several minutes setting up his camera and viewpoint before taking the picture, and while he was doing so, an increasing number of youngsters decided they wanted to become "part of the action". British adults are made of sterner stuff: "Mrs W." would not stoop so low as to be "knowingly" photographed: but when the card was published, she could not resist pointing out to "W.A.W." that it was her in the picture. This reminds us that we are not quite beyond living memory where such photos are concerned. I came across one postcard showing the opening of Ruskin Park in 1903, in which three small children appear. They were the elder brothers of an old lady, whose mother had kept the card because she recognised them: the last brother had just died in 1985. So a careful look at these photographs now may yet produce more identifications of people in them.

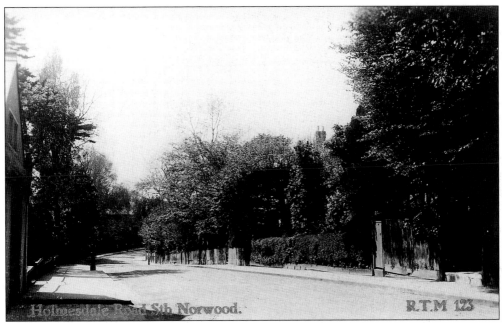

Holmesdale Road, looking down from its junction with South Norwood Hill, still with an industrial unit on the near left. The houses on the right are more modern, but still have fine front gardens, though with fewer trees to block the sunlight.

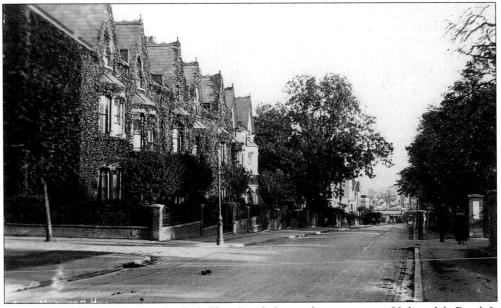

This terrace of houses lies south of Chalfont Road, facing the entrance to Holmesdale Road. It is little changed, though reroofing has removed the top decorative features. The creeper has also gone: attractive though it was, it can damage the brickwork as much as pebble-dashing. The trees in the centre mark the site of the Stanley Memorial Halls, completed in 1909.

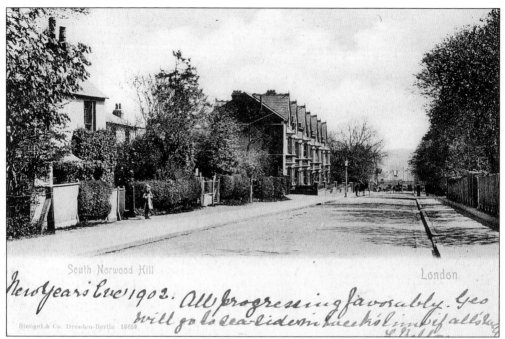

New Years Eve 1902. All progressing favorably. Geo will go to sea-side in weeks time if all is

South Norwood Hill. Taken a bit further uphill, this shows a group of early cottages on the left. Two of them survive: they are now the oldest surviving houses in South Norwood, having been built in the 1830s. That on the right, no 32, Marigold Cottage, had to be repaired after war damage, but no 34, Rose Cottage, is in fine condition.

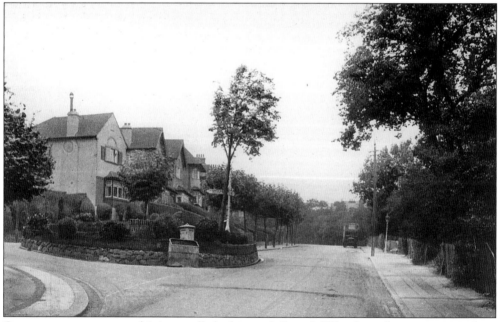

Contrary to appearances, this is actually looking uphill, with Whitehorse Lane coming in from the left. The houses must have been newly built when this photo was taken in about 1920. All except one of the newly planted trees have perished: death from traffic fumes is the most likely cause. The attractive iron signpost is now a Keep Left plastic bollard.

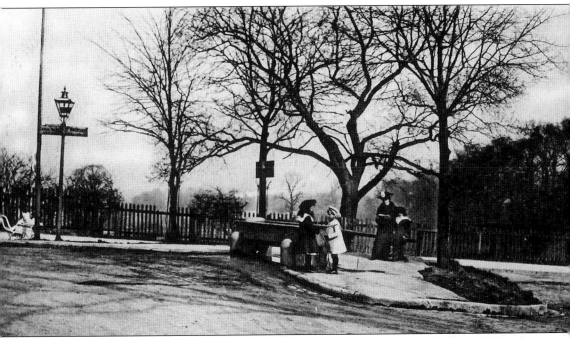

This proved very hard to identify, but the signpost helped. It indicates Crystal Palace to left and Woodside to right, and one can just make out the third arm, which would have pointed to Croydon. So we are at the same point in the Hill, but looking the other way, north-east, in about 1905. In that case, it would have been looking down at South Norwood Lake, and the white streak in the centre must be the Lake. This traffic island, then, was drastically altered when the houses were built in about 1920. The horse trough went, as did the long wooden bench. A proper iron signpost replaced the notices hanging from the street light. Finally, the island was rounded and plants put on it, as seen above.

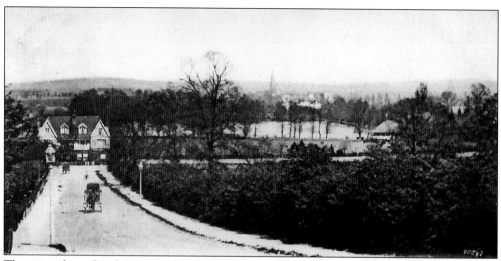

The view from South Norwood Hill in about 1900, though actually taken halfway down Howden Road. The view is now completely obscured by later houses, but at the time, one could see South Norwood Lake, and the boating club building beside it.

Seen from slightly higher up, on a card posted in 1905. By this time the house in Auckland Road, opposite the end of Howden Road, was joined by another. The right half of this house has now gone: one hopes that was the result of enemy action. The closest one can get to this view now, is from near the top of Cypress Road.

Two views of South Norwood Lake c.1920. This was originally the reservoir to provide water for the Croydon Canal, which closed in 1836. This section was later replaced by the railway from Anerley to Norwood Junction. The only parts which now survive of the canal itself are a short stretch, now spoilt by concreting, in Betts Park, Anerley, and a well-preserved, unspoilt section off Dacres Road in Forest Hill.

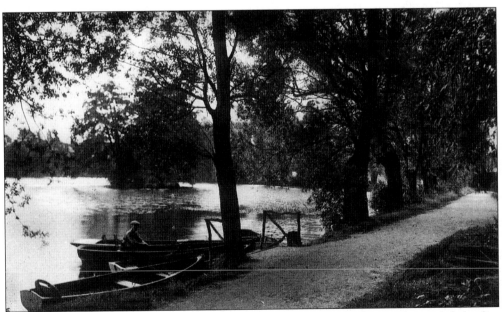

Sailing boats are still often to be seen on the Lake at weekends. The boating house, left derelict for years, was finally renovated and used again in 1998: it is, thank goodness, a listed building, so it cannot be demolished. These two are part of a numbered series of at least nine cards of South Norwood, published in the 1920s by the Photochrom Co.

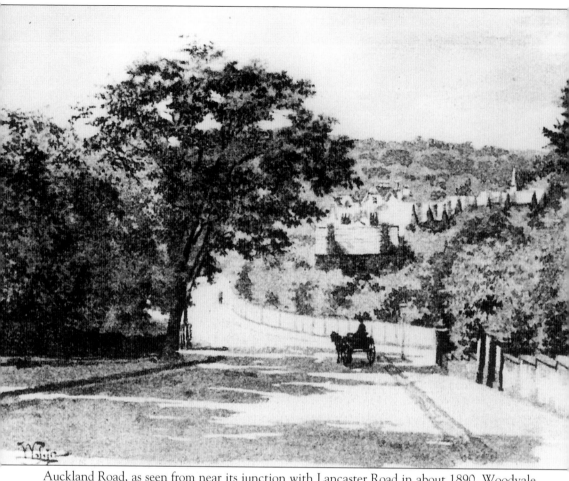

Auckland Road, as seen from near its junction with Lancaster Road in about 1890. Woodvale Avenue runs through the middle of the picture, with the entrance to South Norwood Lake down the road at right. The houses stretch along the east side of Auckland Road as they do now, though obscured by the trees of South Norwood Grounds. But there is no trace of a house on the left hand side: all that was yet to be developed. The single spire in the distance is presumably one of those on St. John's Church.

Nine

Sunnybank

The Sunnybank Estate is unusual in two ways. First, it was enclosed by a large bend of the Croydon Canal, which led naturally to its original name of Frog Island. The Canal was in use from 1809 until 1836, when it was closed to be replaced by the railway. Water survived in the bed of the canal bend for many years therafter, and clearly influenced the layout of the roads around: most of the houses in Lincoln Road and Eldon Park had the old canal at the bottom of their gardens. Secondly, a distinctive series of photographs taken in 1892 by one individual show a large estate which never developed as originally envisaged. Although Sunnybank must have been a delightful rural spot until fairly recently, there are virtually no images of it in earlier days. An exception is this drawing published in 1893, showing nos 12 and 13 Sunnybank, which date from 1851. They survive unaltered in appearance, though 13 is now divided into five flats. The fence to the right of the picture would have had no 70, the old canal cottage, just out of sight to the right. The small driveway seen on the corner is now Bevill Close, leading down to a new housing estate. At the time, it would have led down to the old canal, as did the gardens of nos 12 and 13. What is nice is that the lamp-posts, though new, are in a conservation style, which fits in much better with the surroundings.

The Old Cottage, Sunnybank. This stood on the site of no 70 Sunnybank, and was demolished and replaced by the present 70 in 1936, after the original was condemned as insanitary. Local legend held it was a lock-keeper's cottage, and there is little doubt it dated from the time of the canal.

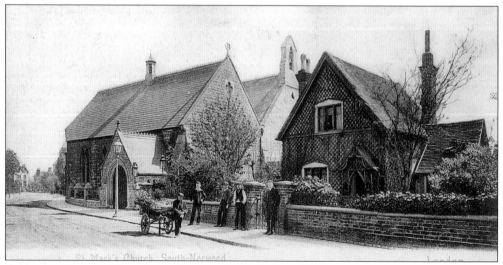

St. Mark's Church, Albert Road, in about 1900. Built in 1853, it acquired a vicar in 1857, who presumably lived in the delightful cottage shown next to the Church. This has now been swallowed up by the utilitarian playground of the church school. In the distance can just be seen the chimneys of 105 Albert Road, a house apparently of the 1850s.

This and the following two photos are a reminder of how some Victorian estates did not prosper. At that time, a builder put up an empty shell, and the buyer, when found, had to make the building inhabitable. Overleaf are shown two series of houses built in 1857. They were never completed, and were demolished in about 1896-7. They were known locally as the Carcases, a name carefully inscribed on the photos by the man who took them. Another such incomplete building appears on the far right in the photo above. The building next to it, with the round-headed window, can be recognised as 19 Eldon Park, and thus enables us to locate the large house on the left, which must have stood roughly at the top end of what is now

Lonsdale Road. The large house, known as Suffolk House, was occupied in 1869 by the Rev. J. B. Wheeler, curate of St. Mark's Church. Note how similar in design it is to two of those shown overleaf: they almost certainly had the same architect. It too was demolished in 1896-7, thus enabling the construction and selling of 30 houses in Lonsdale Road.

The gentleman with the large St. Bernard dog is not identified. But from the fact that he appears in all three photos, he is most likely to have used a timing device to photograph himself, Speculating further, the most likely reason he would have photographed himself at all three sites, was if he had become the owner of the land, and was about to demolish the buildings at all three sites in order to develop the estate. We know who built the carcases in the 1850s, but it should not be impossible to find out the name of the 1897 developer.

These "carcases" stood along Chartham Road, roughly where nos 2-14 now stand. These were built by Gregory; those below by Daynes. Note the two more elaborate turretted buildings flanking simpler ones.

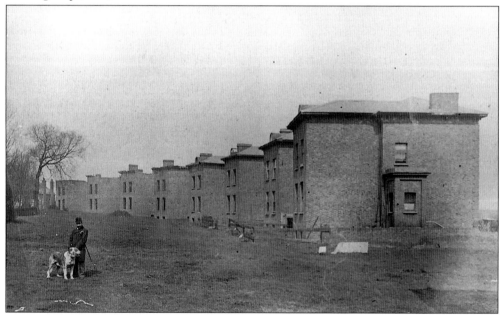

This set of buildings stood where one now finds nos 13-57 Lincoln Road, with the photo taken in what is now their back gardens. Possibly this view shows what would have been their frontages: which would have faced the old canal, at that time disused, but still with water in. A building with a "good outlook" was just as prized then as now! The house with the tall chimneys at the end would have stood just after the junction between Lincoln Road and Regina (formerly Queens) Road.

Ten
Woodside

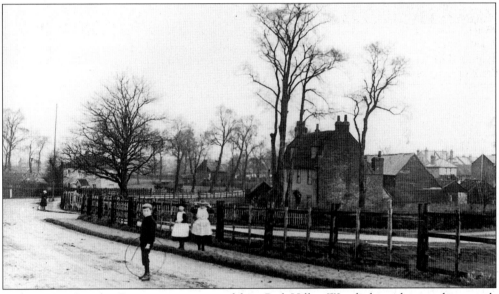

In the 1860s, Croydon Racecourse was moved from Park Hill to Woodside, and situated just south of Long Lane Wood. A station then opened at Woodside for the racegoers and was used by them for thirty years, until the racecourse was moved to Gatwick in 1891. At the date of this photograph, 1892, the area round the station was just a scattering of houses, as seen here. The cottage seen in the distance was later replaced by the whole row of shops along Woodside Green, and by this time the tentacles of South Norwood had reached the Green. Yet despite the presence of tall evergreen trees, we can still see the same viewpoint by standing just north of the railway bridge in Black Horse Lane. And remarkably, the house on the right of the photo, dating from the 17th century, is still there. Sandwiched in between Woodside Green and Elmers Road, this was the old Cherry Tree Farm, and is now a listed building. The farmyard in front is now the forecourt of a car showroom. After a period of dilapidation, the exterior of the building looks good, but it will only regain its full glory when all the cars round it have been removed and it is again used as a dwelling house.

Not many loads of hay travel though Woodside Green now! Though, curiously enough, a drinking trough was installed here after the date of this card (posted 1907). Now filled with flowers, it does keep the rural feel of the scene, looking along Howard Road.

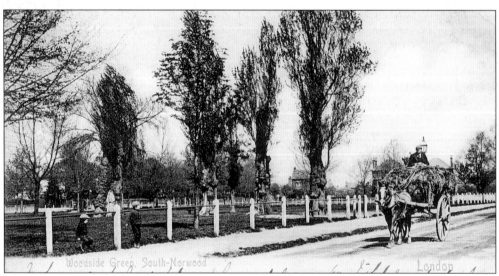

Standing at the same junction on the Green now, one still sees Birchanger Road in the distance. But the scattered houses in the distance have been replaced by a complete line of 1930s residences.

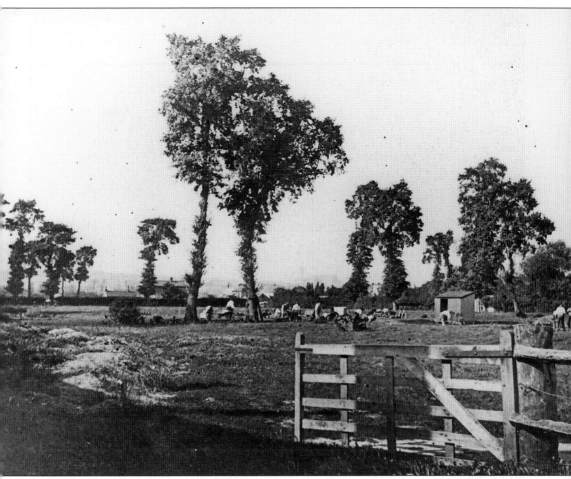

Workmen laying out Sonning Road, Woodside, in the middle of a green field in about 1895. The view looks north from near the High Street, with Crystal Palace and its south tower visible in the distance. Visiting the site in 1995 proved strangely similar: just north of Sonning Road, off Anthony Road, a large open area had been acquired, on which roads and new houses were being constructed. Brickfields Meadows have also been created to provide recreation locally. A low brick arch in the side wall of 1 Malcolm Road, beside Sonning Road, seems to reveal the bridging of a former watercourse at this point.

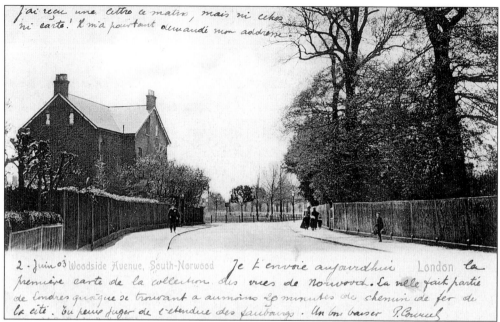

Woodside Avenue, as seen in 1900. The grand house on the left, which appears in some of our other views, was replaced by the line of houses built in the 1930s. Likewise the right-hand side was completely redeveloped at the same time.

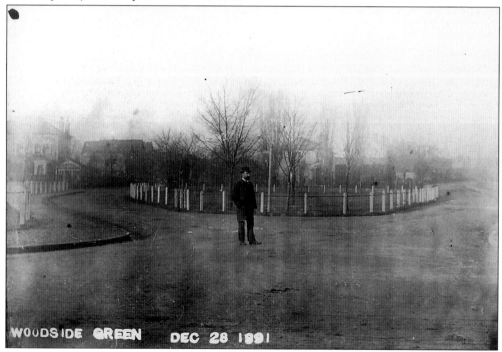

Another view of Woodside Green, but with a caption inscribed underneath, identical to those at Sunnybank. Indeed, the same gentleman who appeared with his St. Bernard dog there, appears here by himself. He can hardly have owned the Green, but may well have lived at Woodside.

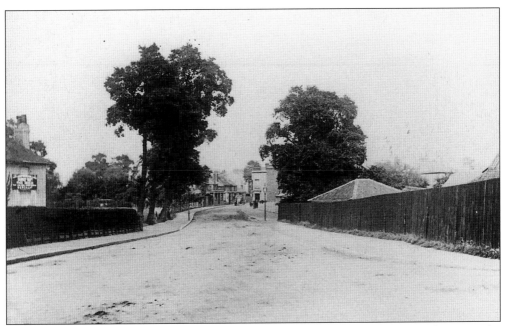

The likelihood of his living at Woodside is increased by these two photographs, part of a collection in a scrap-book now in Croydon Library. These two photos are actually of the same view, seen before and after, as can be deduced from the identical advertising board standing on the same building on the far left of both photographs.

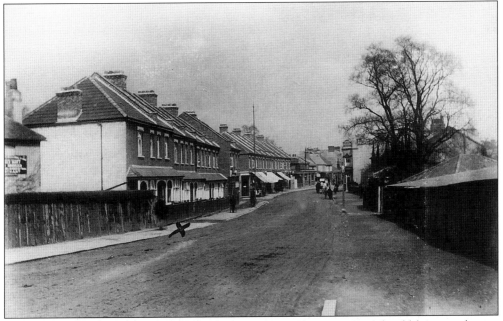

The lower picture probably dates from about 1900, so the upper one should be several years earlier. The principal change is the addition of the line of houses with small front gardens and porches, replacing trees on the left. (They have now been converted into shops.) Perhaps significantly, the compiler of the scrap-book with these photos has placed a cross against these houses. Further evidence that it was he who developed them?

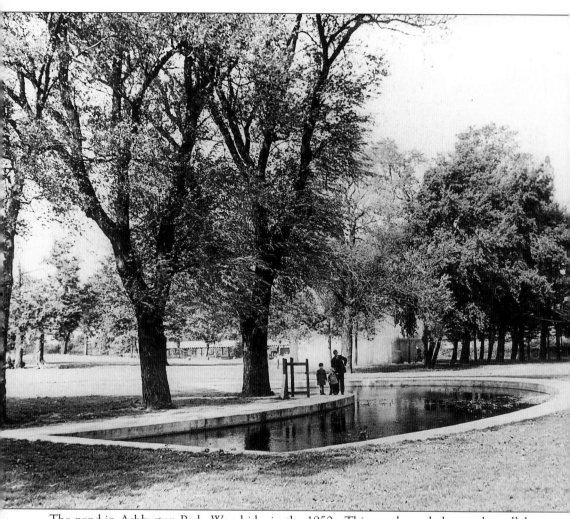

The pond in Ashburton Park, Woodside, in the 1950s. This pond stood close and parallel to Spring Lane - indeed, its water came from the spring after which the Lane got its name. The pond was still there in the 1950s (the author paddled in it!). But all one sees now is a depression, slightly longer grass indicating boggier ground, and a concrete manhole. Like so many ponds in London parks (see South Norwood and Grangewood Recreation Grounds elsewhere in this book), the easiest way to look after a pond, and eliminate the risk of accidental drownings, is to fill it in. Over 80% of London's ponds have been filled in since 1900. The same happens to canals - hence the removal of the Grand Surrey Canal in South London in the 1970s: perhaps we should just be grateful the Thames is not (yet) either filled in or covered over with concrete!

Throughout the last century, this Old Toll House stood at the corner of Long Lane and Spring Lane. It probably dated from 1765, when Spring Lane became one of the turnpike lanes, with tolls to raise money for the upkeep of public highways. The turnpike system was abolished in the 1860s, but this toll house lasted until 1897. A careful examination of the noticeboard on the right indicates that at this time the cottage had become a wayside tavern. One of the gentleman can be seen lifting his tankard, and no doubt the proprietor is also in the picture.

A later view of the toll house, dated 1891. The notice board on the left seems to advertise the imminent sale of both it and the land around: it was demolished in 1897. It is interesting to note that the lettering and date on this photo are identical to the series of three photos discussed under Sunnybank, and the date is just two months earlier. Undoubtedly the same photographer. So could this site also have been developed by the entrepreneur of the Sunnybank Estate?

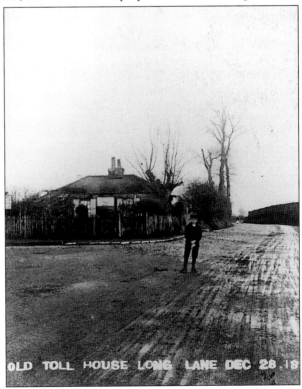

OLD TOLL HOUSE LONG LANE DEC 28.18

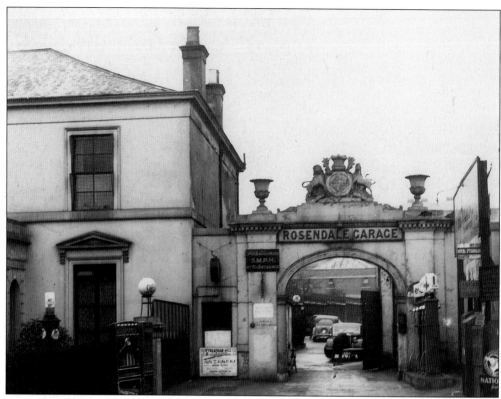

Rosendale Road or The Grand Processional Way that never was. The photo, perhaps from the 1950s, reminds us that Rosendale Road was once grand enough to have its own garage, which stood just up the road from the Rosendale Tavern. But Rosendale Road, south of Park Hall Road, is in fact a long-standing puzzle. Those who walk along it will notice how extremely wide it is. Many of the houses along it are very grand, anything up to five stories high, with balconies on each floor. Just like seaside architecture, in fact, yet the balconies look out over the road, not the sea. They are also almost all by different architects: a curious phenomenon when once expects one or two developers to have built the usual long terraces, or at least several identical buildings. One of the residents in Rosendale Road is Gerald Wells, proprietor of the Vintage Wireless Museum. His great-grandfather built some of the houses in this street, and he told an interesting tale, hitherto unrecorded. 120 years ago, the authorities decided they should have a grand processional way up to the Palace: not the winding narrow routes which everyone had, and still has to use, to get there. So Rosendale Road was built particularly wide to accommodate all the grand carriages of the aristocracy making their way to the Palace. If Gerald's great-grandfather was right, this would also explain the tall buildings and the balconies: providing maximum space for onlookers to admire the grand processions. Likewise it would explain the different builders: because along such a ceremonial route, the cost of leasing building land would have been very high: too much for any one developer to take on more than one house each. But then another developer came along and saw his chance. If he built a road across the bottom of Rosendale Road - where Tritton Road is now - and placed houses along it, the Vestry, in order to continue its Grand Processional Way, would have to buy him out, and pay him massive compensation for all the money he had spent on the houses. So he did build Tritton Road and its houses, and waited for the Vestry to act. His bluff was called. The Vestry refused to buy him out, and dropped the whole idea of the grand processional way. Thus Rosendale Road, which should have been the High Road to the Palace, is now simply a suburban road, curiously wide, with some curiously grand houses along it, and comes to a dead halt at Tritton Road.